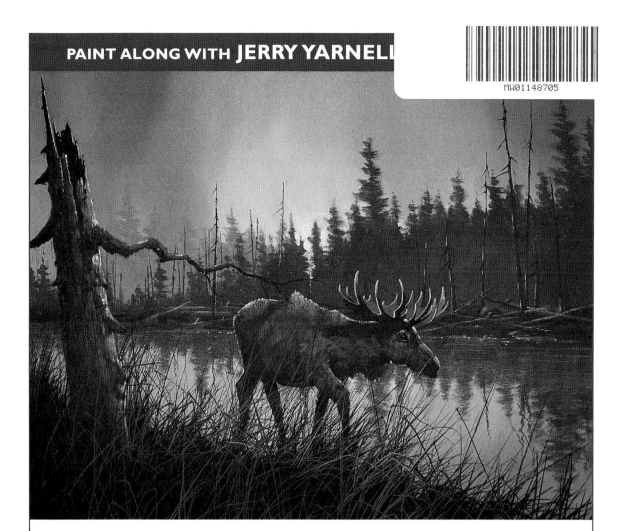

PAINT ALONG WITH **JERRY YARNELL**

PAINTING

Adventures

NORTH
LIGHT
BOOKS

CINCINNATI, OHIO
www.artistsnetwork.com

ABOUT THE AUTHOR Jerry Yarnell was born in Tulsa, Oklahoma, in 1953. A recipient of two scholarships from the Philbrook Art Center in Tulsa, Jerry always has had a great passion for nature, which has become a major theme in his painting. He has been rewarded for his dedication with numerous awards, art shows and gallery exhibits across the country. Yarnell has been honored with the prestigious Easel Award from the *Classic Western Art Show* in Albuquerque, New Mexico; with an exhibition in the Leigh Yawkey Woodson Art Mueseum's annual *Birds in Art* exhibition; as one of the top one hundred in the national *Art for the Parks*

competition; and with representation in an Oil Painters of America show at the Prince Gallery in Chicago, Illinois.

Jerry has another unique talent that makes him stand out from the ordinary: He has an intense desire to share his painting ability with others. For years he has held successful painting workshops and seminars for hundreds of people, and his love for teaching keeps him busy with workshops and private lessons at the Yarnell School of Fine Art. Yarnell has written four books on painting instruction along with the *Paint Along With Jerry Yarnell* series, and you can view his unique style can on the popular PBS television series, *Jerry Yarnell School of Fine Art*, which airs worldwide.

Paint Along with Jerry Yarnell Volume Five: Painting Adventures. © 2002 by Jerry Yarnell. Manufactured in China. All rights reserved. No part of this book may be reproduced in any form or by any electronic or mechanical means including information storage and retrieval systems without permission in writing from the publisher, except by a reviewer, who may quote brief passages in a review. Published by North Light Books, an imprint of F&W Publications, Inc., 4700 East Galbraith Rd., Cincinnati, Ohio 45236. (800) 289-0963. First edition.

Other fine North Light Books are available from your local bookstore or art supply store or direct from the publisher.

06 05 04 03 02 5 4 3 2 1

Library of Congress Cataloging-in-Publication Data

Yarnell, Jerry.
 Paint along with Jerry Yarnell.
 p. cm.
 Includes index.
 Contents: v. 5. Painting adventures
 ISBN 1-58180-319-2 (pbk. : alk. paper)
 1. Acrylic painting—Technique. 2. Landscape painting—Technique. I. Title

ND1535 .Y37 2002
751.4'26—dc21 00-033944
 CIP

Editor: Amanda Metcalf
Interior Layout: Christine Batty
Production Coordinator: John Peavler
Photographer: Scott Yarnell

DEDICATION

It was not difficult to know to whom to dedicate this book. I give God all the praise and glory for my success. He blessed me with the gift of painting and the ability to share this gift with people around the world. He has blessed me with a new life after a very close brush with death. I am here today and able to share all of this with each of you because we have a kind, loving and gracious God. Thank you, God, for all you have done.

Also to my wonderful wife, Joan, who has sacrificed and patiently endured the hardships of an artist's life. I know she must love me or she would not still be with me. I love you, Sweetheart, and thank you. Lastly, to my two sons, Justin and Joshua: You both are a true joy in my life.

ACKNOWLEDGMENTS

So many people deserve recognition. First, I want to thank the thousands of students and viewers of my television show for their faithful support over the years. Their numerous requests for instructional materials are really what initiated the process of producing these books. I want to acknowledge my wonderful staff, Diane, Scott and my mother and father for their hard work and dedication. In addition, I want to recognize the North Light Books staff for their belief in my abilities.

For more information about the Yarnell Studio & School of Fine Art and to order books, instructional videos and painting supplies, contact:

Yarnell Studio & School of Fine Art
P.O. Box 808
Skiatook, OK 74070

Phone: (877) 492-7635

Fax: (918) 396-2846

gallery@yarnellart.com

www.yarnellart.com

METRIC CONVERSION CHART

TO CONVERT	TO	MULTIPLY BY
Inches	Centimeters	2.54
Centimeters	Inches	0.4
Feet	Centimeters	30.5
Centimeters	Feet	0.03
Yards	Meters	0.9
Meters	Yards	1.1
Sq. Inches	Sq. Centimeters	6.45
Sq. Centimeters	Sq. Inches	0.16
Sq. Feet	Sq. Meters	0.09
Sq. Meters	Sq. Feet	10.8
Sq. Yards	Sq. Meters	0.8
Sq. Meters	Sq. Yards	1.2
Pounds	Kilograms	0.45
Kilograms	Pounds	2.2
Ounces	Grams	28.3
Grams	Ounces	0.035

Table of Contents

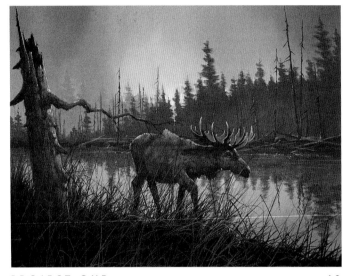

Giant of the Yellowstone

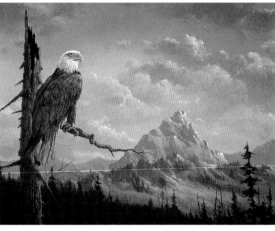

The Guardian

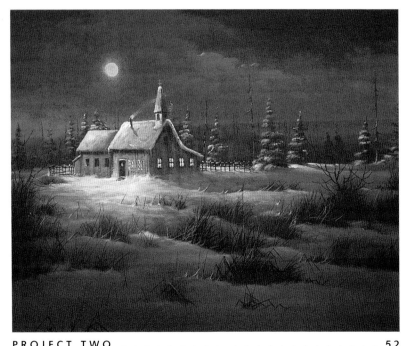

Evening Prayers

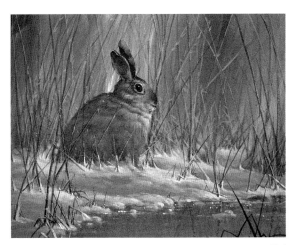

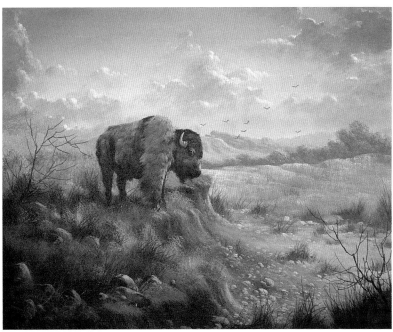

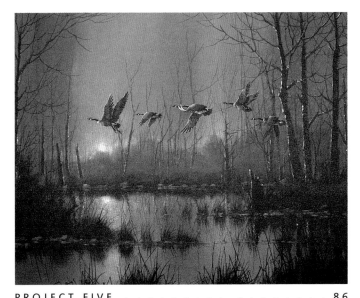

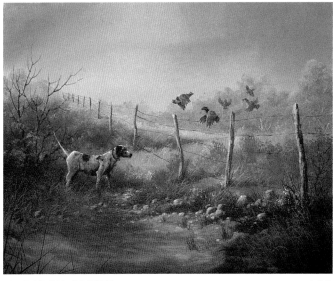

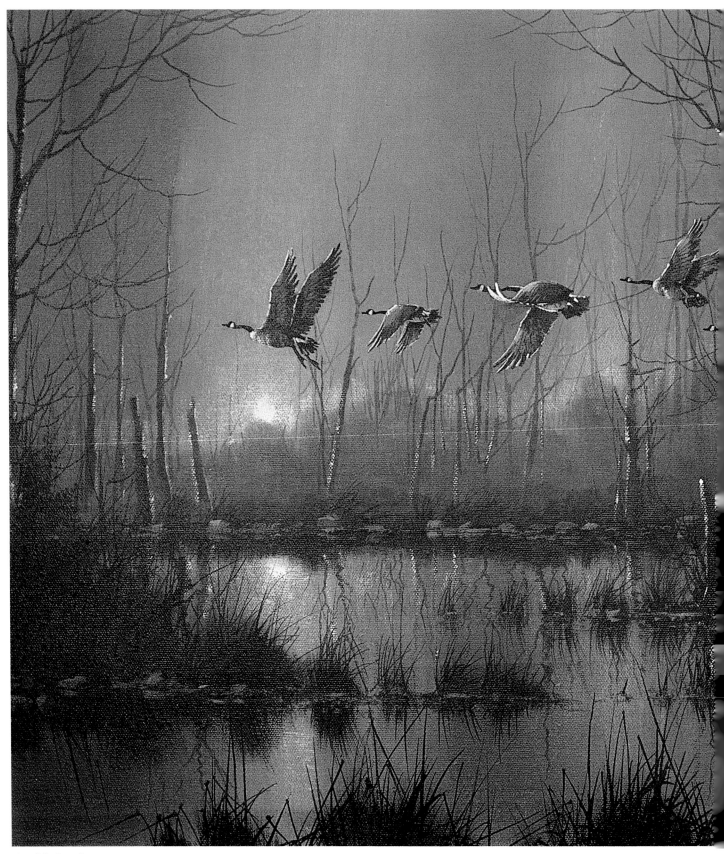

Moonlight Canadians
16" × 20" (41cm × 51cm)

Introduction

Just as the title of this book suggests, painting can—and in fact should be—an adventure. But with adventure comes risk, and to grow as an artist you must be willing to take these risks. Work up the courage to add unique subjects to your paintings, such as birds, animals or people. Adding these subjects will create tremendous eye appeal for your paintings. And the adventure doesn't stop there.

I'll show you which brushes to use for realistic fur, feathers and hair, and you'll learn proper brush use and techniques to get the best aesthetic effects.

I'll discuss proper camera use, types of film, ways to combine photos to create a composite and many other photography tips.

And your painting adventure wouldn't be complete without beautiful, rugged mountaintops, unique cloud formations and night scenes. This painting adventure is really going to be exciting!

Terms & Techniques

Before beginning the step-by-step instructions on the following pages, you may want to refresh your memory by reviewing these terms and techniques.

COLOR COMPLEMENTS

Complementary colors always appear opposite each other on the color wheel. Use complements to create color balance in your paintings. It takes practice to understand how to use complements, but a good rule of thumb is to use the complement or form of the complement of the predominant color in your painting to highlight, accent or gray that color.

For example, if your painting has a lot of green, use its complement, red—or a form of red such as orange or red-orange—for highlights. If you have a lot of blue in your painting, use blue's complement, orange—or a form of orange such as yellow-orange or red-orange. The complement of yellow is purple or a form of purple. Keep a color wheel handy until you have memorized the color complements.

DABBING

Use this technique to create leaves, ground cover, flowers, etc. Take a bristle brush and dab it on your table or palette to spread out the ends of the bristles like a fan (see above example). Then load the brush with the appropriate color and gently dab on that color to create the desired effect.

DOUBLE LOAD OR TRIPLE LOAD

To load a brush this way, put two or more colors on different parts of

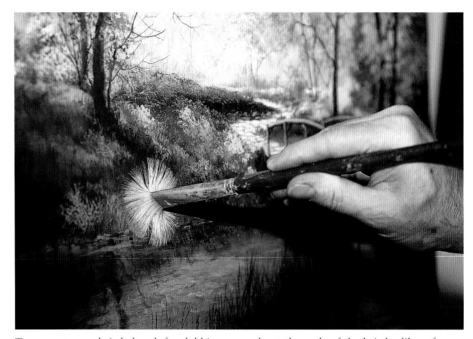

To prepare your bristle brush for dabbing, spread out the ends of the bristles like a fan.

your brush. Mix these colors on the canvas instead of your palette. Double or triple load your brush for wet-on-wet techniques.

DRYBRUSH

Load your brush with very little paint and lightly skim the surface of the canvas with a very light touch to add, blend or soften a color.

EYE FLOW

Create good eye flow and guide the viewer's eye through the painting with the arrangement of objects on your canvas or the use of negative space around or within an object. The eye must move smoothly, or flow, through your painting and around objects. The viewer's eyes shouldn't bounce or jump from place to place. Once you understand the basic components of composition— design, negative space, "eye stoppers," overlap, etc.—your paintings will naturally achieve good eye flow.

FEATHERING

Use this technique to blend to create soft edges, to highlight and to glaze. Use a very light touch, barely skimming the surface of the canvas with your brush.

GESSO

Gesso is a white paint used for sealing canvas before painting on it. Because of its creamy consistency

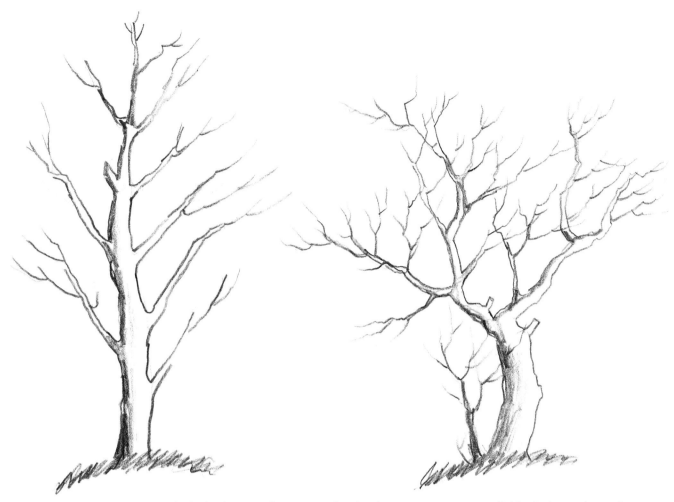

This sketch uses poor negative space. The limbs don't overlap each other, but are evenly spaced so there are few pockets of interesting space.

This sketch uses negative space well. The limbs overlap and include interesting pockets of space.

and because it blends so easily, I often use gesso instead of white paint. When I use the word gesso in my step-by-step instructions, I am referring to the color white. Use gesso or whatever white pigment you prefer.

GLAZE (WASH)
A glaze or a wash is a very thin layer of paint applied over a dry area to create mist, fog, haze or sun rays or to soften an area that is too bright. Dilute a small amount of color with water and apply it to the appropriate area. You can apply the glaze in layers, but each layer must be dry before applying the next.

HIGHLIGHTING OR ACCENTING
Highlighting is one of the final stages of your painting. Use pure color or brighter values to give your painting its final glow. Carefully apply highlights on the sunlit edges of the most prominent objects in your paintings.

MIXING
If you will be using a mixture often, premix a good amount of that color to have handy. I usually mix colors with my brush, but sometimes a palette knife works better. Be your own judge.

I also sometimes mix colors on my canvas. For instance, when I am underpainting grass, I may put two or three colors on the canvas and scumble them together to create a mottled background of different colors. This method also works well well for skies.

When working with acrylics, always mix your paint to a creamy consistency that will blend easily.

NEGATIVE SPACE
Negative space surrounds an object to define its form and create good eye flow (see above example).

Make the value of a color lighter by adding white.

SCRUBBING

Scrubbing is similar to scumbling (below), but the strokes should be more uniform and in horizontal or vertical patterns. Use a dry-brush or wet-on-wet technique with this procedure. I often use it to underpaint or block in an area.

SCUMBLING

Use a series of unorganized, overlapping strokes in different directions to create effects such as clumps of foliage, clouds, hair, grass, etc. The direction of the stroke is not important for this technique.

UNDERPAINTING AND BLOCKING IN

The first step in all paintings is to block in or underpaint the dark values. You'll apply lighter values of each color to define each object later.

VALUE

Value is the relative lightness or darkness of a color. To achieve depth or distance, use lighter values in the background and darker values closer to the foreground. Lighten a color by adding white. Make a value darker by adding black, brown or the color's complement.

WET-ON-DRY

I use this technique most often in acrylic painting. After the background color is dry, apply the topcoat by drybrushing, scumbling or glazing.

WET-ON-WET

Blend the colors together while the first application of paint is still wet. I use a large hake (pronounced ha KAY) brush to blend large areas, such as skies and water, with the wet-on-wet technique.

Getting Started

Acrylic Paint

The most common criticism of acrylics is that they dry too fast. Acrylics do dry very quickly because of evaporation. To solve this problem I use a wet palette system (see pages 13-15). I also use very specific dry-brush blending techniques to make blending very easy. With a little practice you can overcome any of the drying problems acrylics pose.

Speaking as a professional artist, acrylics are ideally suited for exhibiting and shipping. You actually can frame and ship an acrylic painting thirty minutes after you finish it. You can apply varnish over an acrylic painting, but you don't have to because acrylic painting is self-sealing. Acrylics are also very versatile because you can apply thick or creamy paint to resemble oil paint or paint thinned with water for watercolor techniques. Acrylics are non-toxic with very little odor, and few people have allergic reactions to them.

USING A LIMITED PALETTE

I work from a limited palette. Whether for professional or instructional pieces, a limited palette of the proper colors is the most effective painting tool. It teaches you to mix a wide range of shades and values of color, which every artist must be able to do. Second, a limited palette eliminates the need to purchase dozens of different colors.

With a basic understanding of the color wheel, the complementary color system and values, you can mix thousands of colors for every type of painting from a limited palette.

For example, mix Phthalo Yellow-Green, Alizarin Crimson and a touch of Titanium White (gesso) to create a beautiful basic flesh tone. Add a few other colors to the mix to create earth tones for landscape paintings. Make black by mixing Ultramarine Blue with equal amounts of Dioxazine Purple and Burnt Sienna or Burnt Umber. The list goes on and on, and you'll see that the sky isn't even the limit.

Most paint companies make three grades of paints: economy, student and professional. Professional grades are more expensive but much more effective. Just buy what you can afford and have fun. Check your local art supply store first. If you can't find a particular item, I carry a complete line of professional- and student-grade paints and brushes (see page 3).

MATERIALS LIST

Palette

white gesso
Grumbacher, Liquitex or Winsor & Newton paints (color names may vary):

- Alizarin Crimson
- Burnt Sienna
- Burnt Umber
- Cadmium Orange
- Cadmium Red Light
- Cadmium Yellow Light
- Dioxazine Purple
- Hooker's Green Hue
- Phthalo (Thalo) Yellow-Green
- Titanium White
- Ultramarine Blue

Brushes

no. 4 flat sable brush
no. 4 round sable brush
no. 4 script liner brush
no. 6 flat bristle brush
no. 10 flat bristle brush
2-inch (51mm) hake brush

Miscellaneous Items

16" × 20" (41cm × 51cm) stretched canvas
charcoal pencil
easel
no. 2 soft vine charcoal
palette knife
paper towels
Sta-Wet palette
spray bottle
water can

Brushes

I use a limited number of brushes for the same reasons as the limited palette—versatility and economics.

2-INCH (51MM) HAKE BRUSH

Use this large brush for blending, glazing and painting large areas, such as skies and bodies of water with a wet-on-wet technique.

NO. 10 FLAT BRISTLE BRUSH

Underpaint large areas—mountains, rocks, ground or grass—and dab on tree leaves and other foliage with this brush. It also works great for scumbling and scrubbing techniques. The stiff bristles are very durable so you can treat them fairly roughly.

NO. 6 FLAT BRISTLE BRUSH

Use this brush, a cousin of the no. 10 flat bristle brush, for many of the same techniques and procedures. The no. 6 flat bristle brush is more versatile than the no. 10 because you can use it for smaller areas, intermediate details and highlights. You'll use the no. 6 and no. 10 flat bristle brushes most often.

NO. 4 FLAT SABLE BRUSH

Use sable brushes for more refined blending, details and highlights, such as final details, painting people and adding details to birds and other animals. Treat these brushes with extra care because they are more fragile and more expensive than bristle brushes.

NO. 4 ROUND SABLE BRUSH

Use this brush, like the no. 4 flat sable, for details and highlights. The sharp point of the round sable, though, allows more control over areas where a flat brush will not work or is too wide. This is a great brush for finishing a painting.

NO. 4 SCRIPT LINER BRUSH

This brush is my favorite. Use it for very fine details and narrow line work, such as tree limbs, wire, weeds and especially your signature, that you can't accomplish with any other brush. Roll the brush in an ink-like mixture of pigment until the bristles form a fine point.

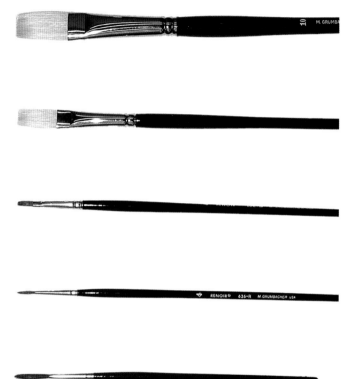

You can paint any subject with this basic set of brushes.

BRUSH-CLEANING TIPS

As soon as you finish your painting, use quality brush soap and warm water to clean your brushes thoroughly before the paint dries. Lay your brushes flat to dry. Paint is very difficult to get out if you allow it to dry on your brushes or clothes. If this does happen, use denatured alcohol to soften the dried paint. Soak the brush in the alcohol for about thirty minutes and then wash it with soap and water.

Palettes

Several palettes on the market are designed to keep paints wet. I use two Sta-Wet palettes made by Masterson. Acrylics dry because of evaporation, so keeping the paints wet is critical. The first palette is a 12" × 16" (31cm × 41cm) plastic palette-saver box with an airtight lid (see page 14). Saturate the sponge that comes with the palette with water and lay it in the bottom of the box. Then soak the special palette paper and lay it over the sponge. Place your paints around the edges and you are ready to go. Use a spray bottle to mist your paints occasionally so they will stay wet all day long. When you are finished painting, attach the lid and your paint will stay wet for days.

My favorite palette is the same palette with a few alterations (see page 15). Instead of the sponge and special paper, I place a piece of double-strength glass in the bottom of the palette. I fold paper towels into quarters to make long strips, saturate them with water and lay them on the outer edges of the glass. I then place my paints on the paper towels. They stay wet for days. I occasionally mist them to keep the towels wet.

If you leave your paints in a sealed palette for several days without opening it, certain colors, such as Hooker's Green Hue and Burnt Umber, will mildew. Just replace the color or add a few drops of chlorine bleach to the water in the palette to help prevent mildew.

To clean the glass palette, allow it to sit in water for about thirty seconds or spray the glass with your spray bottle. Scrape off the old paint with a single-edge razor blade.

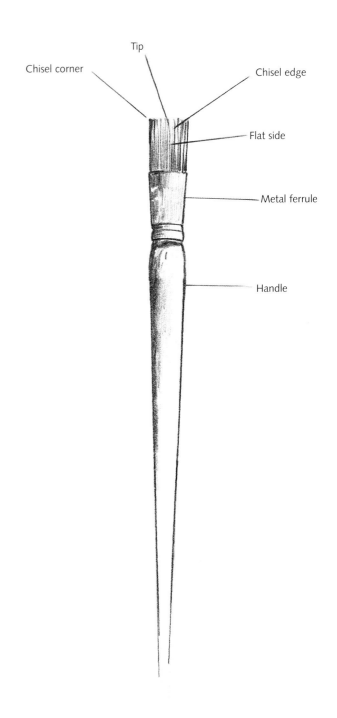

Tip

Chisel corner

Chisel edge

Flat side

Metal ferrule

Handle

Two Ways to Set Up Your Palette

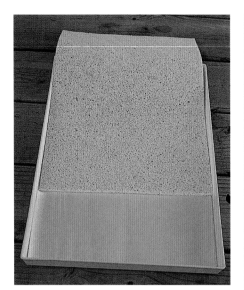

The Sta-Wet 12" × 16" (31cm × 41cm) plastic palette-saver box comes with a large sponge that you saturate with water.

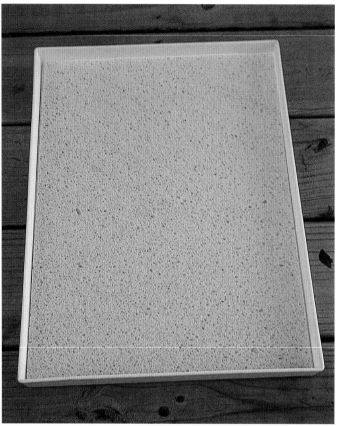

Lay the sponge inside the palette box, soak the special palette paper and lay it over the sponge. Place your paints around the edges. Don't forget to mist them to keep them wet.

When closing the palette-saver box, make sure the airtight lid is on securely. When the palette is properly sealed, your paints will stay wet for days.

Instead of using the sponge and palette paper, you can use a piece of double-strength glass in the bottom of the palette. Fold paper towels in long strips and saturate them with water.

Lay the saturated paper towels around the outer edges of the glass.

Place your paints on the paper towel strips.

Use the center of the palette for mixing paints. Occasionally spray a mist over the paper towels to keep them wet.

To clean the palette, allow it to sit for thirty seconds in water or spray the glass with a spray bottle. Scrape off the old paint with a single-edge razor blade.

Miscellaneous Supplies

CANVAS

Canvas boards work for practicing strokes, and canvas paper pads work for studies or testing paints and brush techniques. The best surface for painting, though, is a primed, pre-stretched cotton canvas with a medium texture, which you can find at most art stores. As your skills advance, you may want to learn to stretch your own canvas, but 16" × 20" (41cm × 51cm) pre-stretched cotton canvases are all you'll need for the paintings in this book.

EASEL

I prefer a sturdy, standing easel. My favorite is the Stanrite ST500 aluminum easel. It is lightweight, sturdy and easy to fold up to take on location or to workshops.

LIGHTING

Of course, the best light is natural north light, but most of us don't have this light in our work areas. The next best lighting option is to hang 4' (1.2m) or 8' (2.4m) fluorescent lights directly over your easel. Place one cool bulb and one warm bulb in the fixture to best simulate natural light.

Studio lights

16" × 20" (41cm x 51cm) stretched canvas

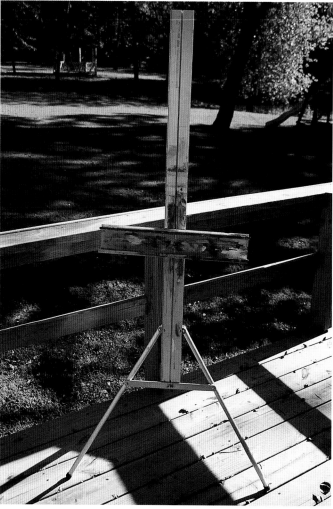

Stanrite aluminum studio easel

SPRAY BOTTLE

I use a spray bottle with a fine mist to lightly wet my paints and brushes throughout the painting process. I recommend a spray bottle from a beauty supply store. It's important to keep one handy.

PALETTE KNIFE

I use my palette knife more for mixing than for painting. A trowel-shaped knife is more comfortable and easier to use than a flat knife.

SOFT VINE CHARCOAL

I use no. 2 soft vine charcoal for most of my sketching. It's very easy to work with, shows up well and is easy to remove with a damp paper towel.

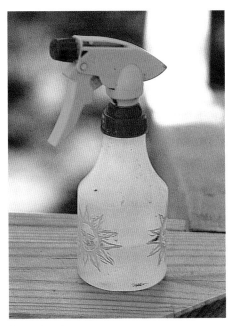

Spray bottle

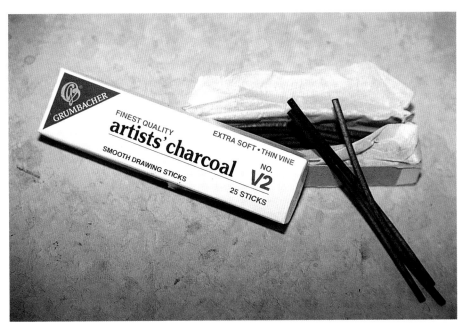

Soft vine charcoal

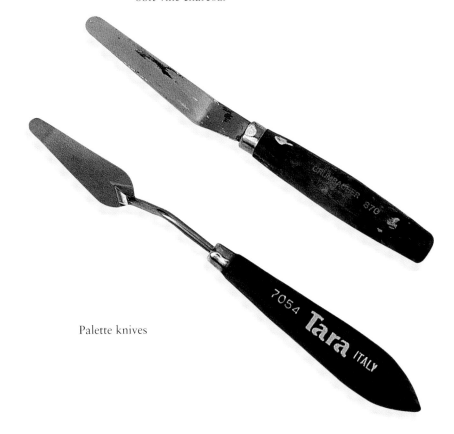

Palette knives

Adding Wildlife

The most important part of adding wildlife to a painting is to determine if the wildlife will be the focal point of your painting or simply an accent. We'll examine both possibilities.

Wildlife as Accents

First, we'll look at wildlife as an accent or added object within the composition. Landscape artists who want to give their paintings more life and interest can benefit from this use of wildlife.

Paint your landscape without concentrating on the fact that you'll add wildlife later. Once you've finished painting your landscape, refer to your reference material of the wildlife, whether it is a photo or a rough sketch. Decide where you want to place the wildlife within your painting.

Once you've decided on the type of wildlife you're going to use, make a rough sketch over the painting with no. 2 soft vine charcoal. You can wipe soft vine charcoal off dry surfaces with a damp paper towel. If you don't want to wait for the painting to dry, make two or three thumbnail sketches of your basic composition on scrap paper to decide where to place the wildlife. Then paint the wildlife into the painting.

Look at the following examples.

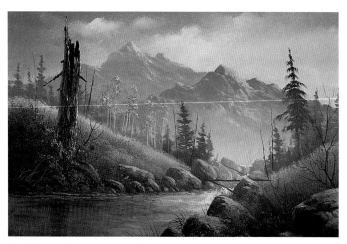

Landscape Without Wildlife
Let's put a deer in this painting. Because the deer is only an accent, don't place it too far forward in the scene or make it too large or too detailed.

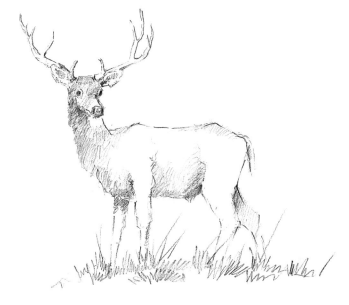

Reference Drawing
Use this reference sketch to draw the deer onto the painting. You probably won't find the correct placement the first time, so don't be afraid to sketch it in and wipe off mistakes several times. The following examples are just a few possibilities.

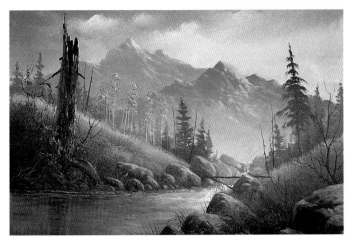

Incorrect Placement

The deer is too close to the side of the painting. It becomes an eye catcher and detracts from the composition.

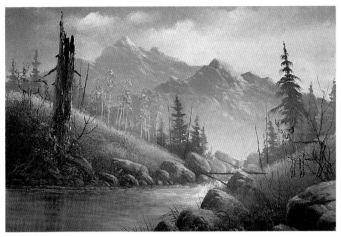

Incorrect Placement

The deer competes for attention with the focal point, which is the area in front of the waterfall where the logs cross the stream. It overpowers the center of interest and again detracts from the natural eye flow.

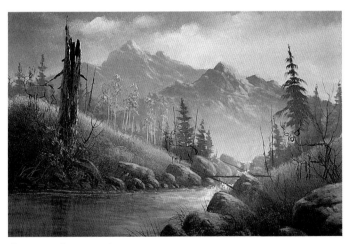

Correct Placement

The deer fits nicely into the composition when it is in the background. It does not compete with the center of interest and is not an eyesore.

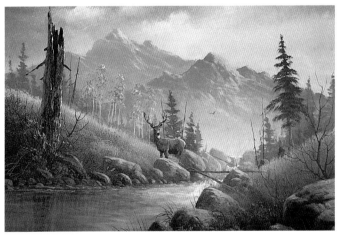

Final Painting

Once you determine a good location for the deer, paint it in with the correct value and degree of detail. Because this deer is in the background, it should be fairly light and doesn't need too much detail.

Mountain Majesty
18" × 24" (46cm × 61cm)

Follow this simple process when adding wildlife to a painting as an accent:

1. Finish the painting.
2. Choose a wildlife image, a sketch or a photo, from your reference material.
3. Make several rough sketches to determine the placement of the wildlife. Draw over a painting with soft vine charcoal or make several thumbnail sketches.
4. Determine the accurate size of the wildlife in relation to other objects in the same area.
5. Determine the proper value, depending on the placement of the wildlife within the painting.
6. Paint in the wildlife with the right amount of detail.

Wildlife as Centers of Interest

When using wildlife as the center of interest, design the landscape around the wildlife rather than making it fit into the existing landscape.

Wildlife as Accents

Notice how much the swan adds to the painting without competing with the center of interest.

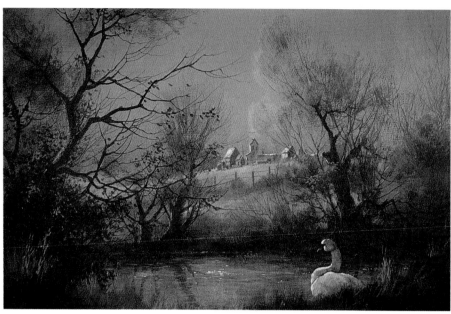

Lonesome Swan
12" × 18" (30cm × 46cm)

Wildlife as Centers of Interest

In this painting, the mother giraffe and her baby form the focal point, and the landscape is secondary.

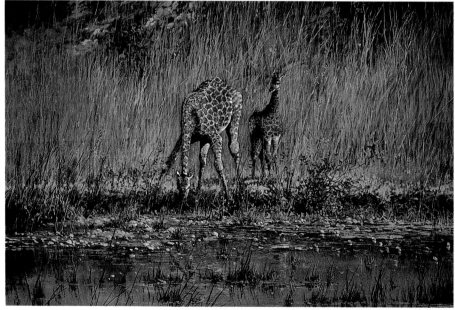

So That's How It's Done
24" × 30" (61cm × 76cm)

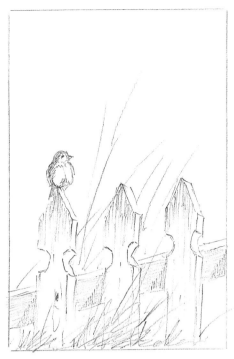

Bad Composition

This composition didn't suit me. Everything lines up too evenly, which creates bad negative space.

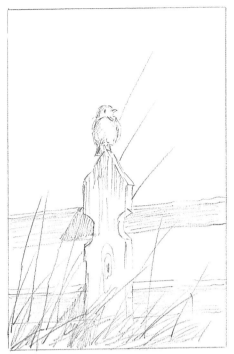

Bad Composition

I wasn't happy with this composition either. The fence post and the bird are too centered, which again creates uninteresting negative space. Let's try again.

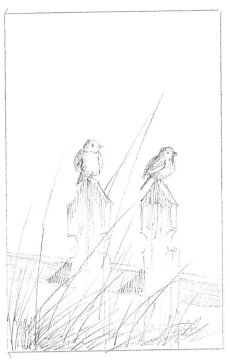

OK Composition

We're getting closer. I like the two birds and two fence posts, but the composition and negative space still are not quite right. Let's try one more time.

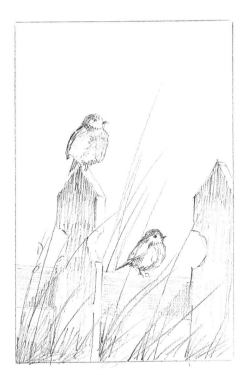

Good Composition

I moved the posts farther apart to create a nice pocket of negative space for the second bird to sit in. I also angled the cross board.

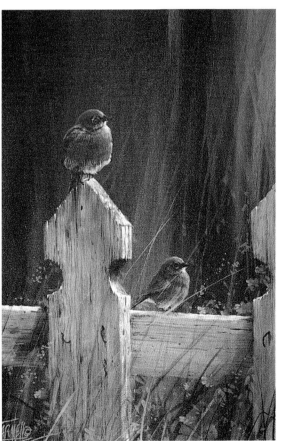

Final Painting

Drawing several thumbnail sketches allows you to study possible compositions and work out any problems in advance of painting.

In this painting, just as in the giraffe painting on page 20, the wildlife is the feature and the landscape is secondary. When wildlife serves as your center of interest, don't neglect good painting habits when it comes to the background. Paint an artistically sound landscape without letting it compete with the wildlife.

Two of a Kind
12" × 16" (30cm × 41cm)

Adding People

The process of adding people to your paintings is identical to our study of wildlife.

 Adding people to your landscapes can be very rewarding if done properly. A common concern is the proportion of people or animals in relation to other objects in the painting.

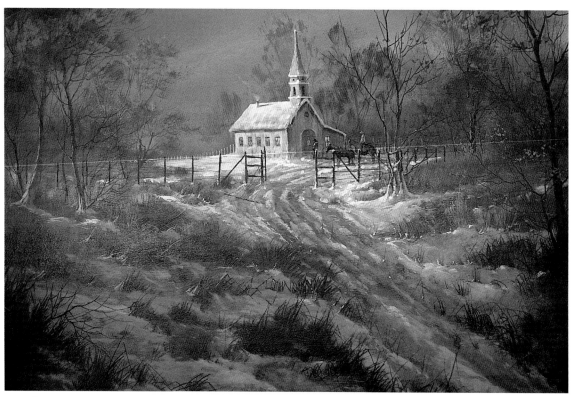

People as Accents

The cowboys and their horses blend well with the center of interest, the church, and they are proportional to other objects on the same plane. Notice that the cowboys and the rest of the landscape do not compete with each other. Compatibility is the key to adding people to your paintings, just as it is when adding wildlife.

Church in the Wildwoods
18" × 24" (46cm × 61cm)

Proportioning With Planes

Once you've completed your landscape and decided where you want to put the people or animals, draw a horizontal line all the way across the canvas with no. 2 soft vine charcoal at the height at which you want to place the figure. Look at every object on the plane formed by this line. Make sure your person or animal is in proportion to the other objects *standing on* that plane. Common sense plays a vital role in this process.

Every object on your canvas stands on a plane, and each object must appear in proportion to every other object standing on the same plane. As an object recedes into the distance, it becomes smaller, and other objects on the same plane also become smaller. With a little practice you'll master your observation skills and begin to relate objects to each other using proportion and planes.

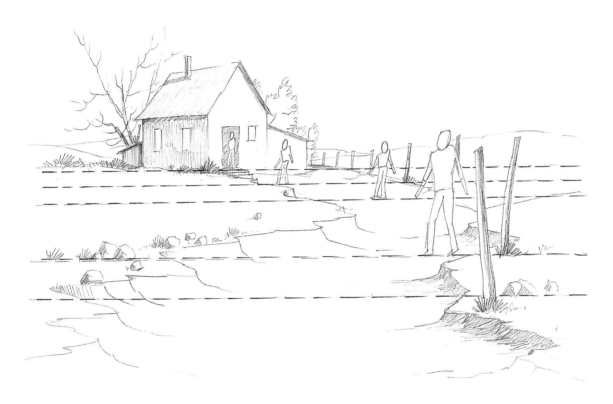

Planes and Proportions

I decided to add a person next to the cabin in this drawing. I drew a line across the canvas with soft vine charcoal. Good judgment tells me that the person cannot be larger than the cabin, and he or she must be small enough to fit through the door. If I wanted to place the person closer to the foreground, I would draw another line and make the person proportional to other objects on the new plane.

Objects should be the same proportion as other objects *standing on* the same plane. For example, the figure closest to the foreground should be the same proportion as the rocks on the same line, not the post closest to the foreground, which sits on another line/plane.

Painting Fur, Feathers and Hair

Bristle Brush

Bristle brushes have very stiff, coarse hairs. This brush works best for blocking in or underpainting an animal's form before adding details. It's very tough, so you can use it to scrub, scumble and smudge. It's too coarse and stiff to create soft fur, feathers or hair. You'll use a bristle brush for underpainting. I use two bristle brushes—a no. 4 and a no. 6. Don't hesitate to experiment with other sizes to see what works best for you. Bristle brushes come in two bristle lengths, long and short. I prefer long bristles because they are more flexible.

Sable Brush

Most artists who paint fur, feathers and hair use a sable brush. The sable brush is flexible, holds its form and has very fine hairs that work well for extreme detail. It's more expensive than other brushes but well worth the investment.

A sable brush is very delicate, so you can't treat it as harshly as you can a bristle brush. It comes in several varieties, such as blended—50 percent sable, 50 percent synthetic— and pure red kolinsky sable. Whatever fits your price range will do.

I use two medium-quality sables that I manufacture—a round and a flat. The no. 4 round and no. 4 flat sable brushes are my favorites, but I also use larger brushes for bigger projects.

Synthetic Brush

A cheaper alternative to the sable brush is the synthetic brush. A synthetic brush has man-made bristles designed to feel like the more expensive red sable. It falls short of a sable brush in flexibility and control and is more useful for painting coarser hair and fur.

Whenever I mention a sable brush in a demonstration, though, feel free to substitute a synthetic brush. You may be quite satisfied.

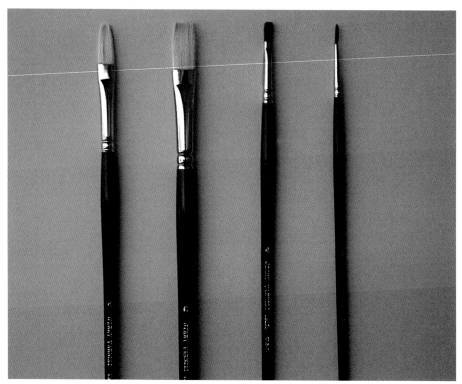

Brushes
The most commonly used brushes for fur, feathers and hair are shown from left to right: no. 4 flat bristle, no. 6 flat bristle, no. 4 flat sable and no. 4 round sable.

When to Use These Brushes

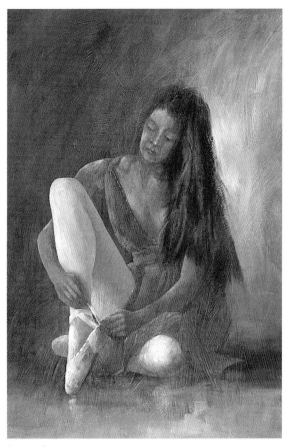

Contemplation
20" × 16" (51cm × 41cm)

Hair
I underpainted the long, flowing hair on this ballerina with a rich, brown tone using a no. 6 flat bristle brush. Then, I took my no. 6 synthetic brush to add the highlights and form. I switched to a no. 4 round sable brush to paint in the stray hairs. The hair is a bit more impressionistic, so I used loose, feathery strokes with a fairly creamy mixture.

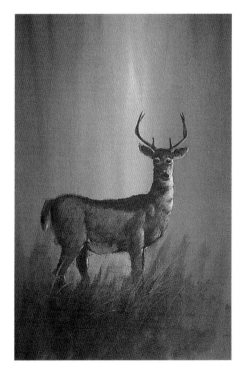

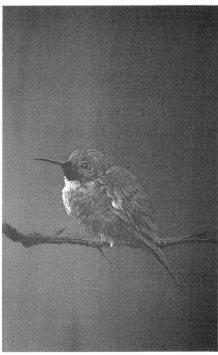

Fur and Feathers
I needed a sable brush for the detail work on these studies because the fur and feathers are much more refined than the ballerina's hair. I underpainted the base body form with a no. 4 flat bristle brush. I mixed the highlight color until it was slightly creamy. Then, I loaded the end of the brush and used light, short, feathery strokes to suggest the hair on the deer and the feathers on the hummingbird.

Painting Mountains

Most artists love to paint mountains. They're intriguing and exciting and definitely adventurous. They can be difficult as well as the most rewarding subjects you could ever learn to paint. Knowing what makes a bad mountain can help you understand what makes a good one.

Start with a good design. The most common mistake when painting mountains is making each mountain or range similar in shape. Repetition of shapes seems to be a part of human nature, but it can be a disaster when composing an interesting mountain range.

Poor Use of Negative Space
Notice how uninteresting this arrangement is. All of the peaks are the same. Repeating the shape of even the most beautiful mountain in the world will ruin a composition.

Proper Use of Negative Space
This arrangement is much more interesting. Unusual pockets of negative space and overlapping peaks create better eye flow and make the scene much more appealing and fun.

1 Draw Basic Sketch

Apply a liberal coat of gesso over the sky. While it is still wet, add touches of Cadmium Yellow Light and Cadmium Orange at the horizon and blend about a quarter of the way to the top of the canvas. Add Ultramarine Blue and touches of Burnt Sienna at the top of the canvas and blend down with large crisscross stokes. Where the colors meet, feather them together with a hake brush.

Getting down to business, create a basic sketch of the mountains over the washes you painted for the sky with no. 2 soft vine charcoal. Work out your mountain design in advance to get the mountain off on the right foot.

2 Mix Base Gray

Mix three values—one for each mountain range in this exercise—to create depth. The mountains will get lighter as they move back in the painting. Mix a base gray color of Titanium White (gesso), some Ultramarine Blue, a touch of Burnt Sienna and just a little Dioxazine Purple. I like a slightly purple gray because it helps create depth. Your base color does not have to match this swatch perfectly.

3 Underpaint Distant Mountain Range

To create the most distant value, add enough Titanium White (gesso) to some of the base gray mixture to make it slightly darker than the sky. Use a no. 6 flat bristle brush to scrub in the basic shape of the first mountain range, keeping the edges fairly soft.

4 Underpaint Middle Mountain Range

Take some more of the base gray mixture and add less Titanium White (gesso) to make this mixture slightly darker than the color you mixed in step 3. Use a no. 6 flat bristle brush to scrub in the second mountain range.

5 Underpaint Closest Mountain Range

Again add a little less Titanium White (gesso) to the base mixture to make it slightly darker than the color you used in step 4. Scrub in the closest mountain range using a no. 6 flat bristle brush.

6 Mix Highlight Color

Mountains can be all different colors. This mixture—Titanium White (gesso) and a touch each of Cadmium Yellow Light and Cadmium Orange—is a basic highlight color. Don't be afraid to experiment with other colors.

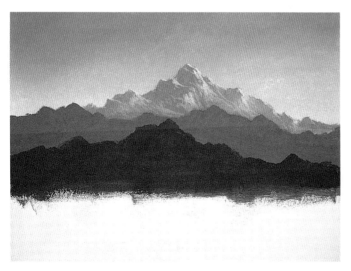

7 Highlight Distant Mountain Range

Establish the direction of the light source before you add highlights. The light in this demonstration shines from the upper right. Make some of the highlight mixture slightly creamy, and load a small amount on the end of a no. 4 flat sable brush. Start at the top of the first mountain range, and using short, choppy dry-brush strokes add highlights to give the mountain its form. Make sure your strokes have a left-to-right movement to indicate the light source. Keep the edges of the highlights soft so they blend into the base color. Whenever you're highlighting, use negative space well. Don't repeat the same highlight shapes. This is a common mistake and an easy one to fall into. Make subtle changes in the directions of your strokes as you go.)

8 Highlight Middle Mountain Range

The middle mountain range is the largest of the three, so it will have the most details. Brighten the highlight mixture with more Cadmium Yellow Light and Cadmium Orange. Again, paint unique and interesting highlight shapes with a no. 4 flat sable brush.

9 Highlight Closest Mountain Range

Again brighten the value slightly and use a no. 4 flat sable brush to highlight the mountain range closest to the foreground. Be careful not to make it too busy.

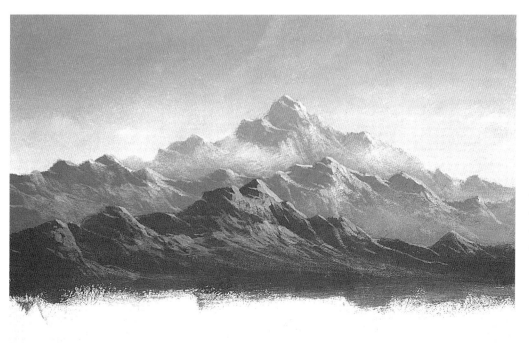

10 Add Finishing Touches

To finish the painting, you could add snow, fog, mist or haze to create an interesting mood. You may choose just to brighten the highlights. I chose to add fog between the mountain ranges and brighten the highlights on the middle mountain range. Just experiment and have fun!

Painting Night Scenes

This is an area of painting that has intrigued artists forever. The secret to a good night scene is *contrast*. You just have to know how to make contrast work properly so the painting takes on the characteristics of night and the season.

You can best learn to paint a night scene when it is in a winter setting. Night scenes have rich, dark colors and values; soft, warm, glowing light from stars, the moon, windows, a street lamp or a campfire; silhouettes; well-defined forms in shadows and cast shadows; silver linings or accent highlights on the edges of objects and few or no details.

So how do you put all of these components together to create a night scene? Following is an example of how to do just that. The demonstration for *Evening Prayers* on page 52 will take you through a more in-depth, step-by-step process.

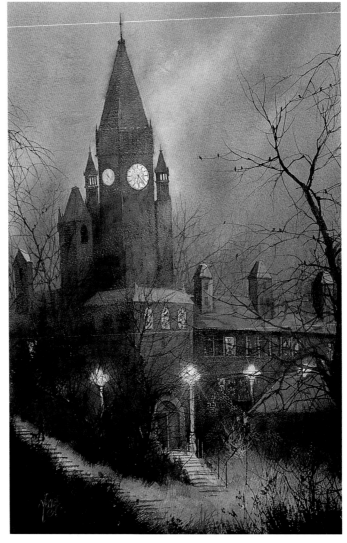

Watercolor Study
I painted this watercolor study to prepare for a larger acrylic painting. Notice the warm glow and the soft haze surrounding the light from the windows and street lamp. This haze really adds to the mood of the scene.

Light Study
To create this glow, paint the actual light with an opaque mixture of Cadmium Yellow Light and Cadmium Orange. Then, add a small amount of Titanium White (gesso) to the mixture and smudge in a little bit of a haze around the light with a very dry brush.

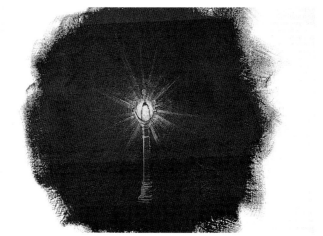

1 Mix Sky Color

The most important component in a night scene is, obviously, the sky. Mix Ultramarine Blue and touches of Dioxazine Purple, Burnt Sienna and Hooker's Green Hue.

2 Underpaint Sky

Paint in the sky with the mixture from step 1 using a hake brush. Add a mixture of Titanium White (gesso) and a touch of Cadmium Orange at the horizon line. Blend the mixture about halfway up the sky, keeping the edges very soft.

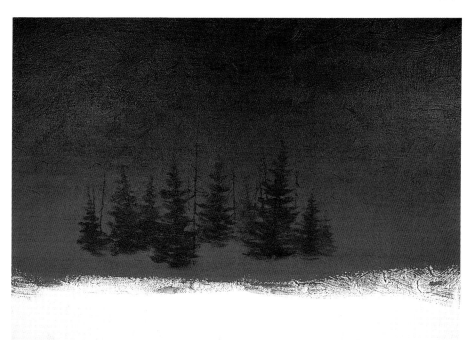

3 Underpaint Trees

Using a no. 4 flat bristle brush and the original sky mixture, paint in a small collection of trees. Keep the edges soft so the contrast is not too harsh. Use a no. 4 script liner with an inky version of this mixture to paint the dead trees.

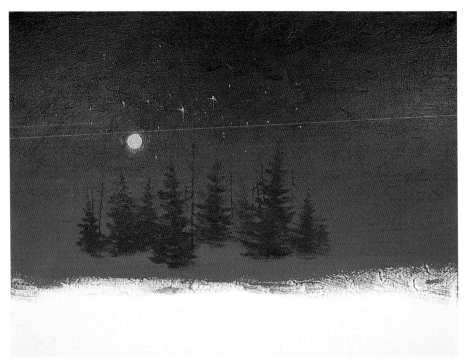

4 Add Moon and Stars

Use a no. 4 flat sable brush and a mixture of Titanium White (gesso), touches of Cadmium Yellow Light and Cadmium Orange and a hint of Ultramarine Blue to slightly gray the mixture to block in the moon's shape. Dab in the stars with a no. 4 round sable brush. Drybrush some very faint light rays, pulling paint from the stars while they are still wet.

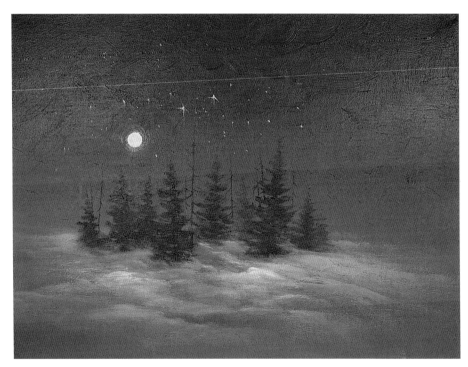

5 Underpaint Snow

Block in the snow with a mid-tone gray mixture of the base sky mixture and Titanium White (gesso). After this dries, highlight the snow with a mixture of Titanium White (gesso) and a touch each of Cadmium Yellow Light and Cadmium Orange.

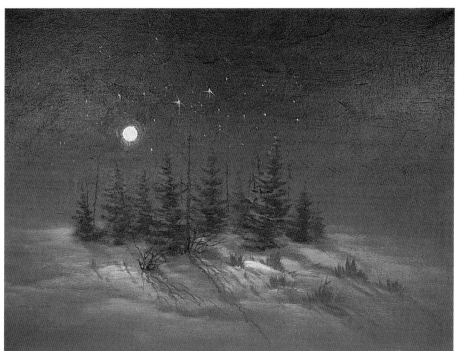

6 Add Trees and Shadows

Add a couple of trees and a few clumps of grass with the base sky mixture. Make this mixture slightly lighter with Titanium White (gesso), and drybrush shadows from all of the trees with a no. 4 flat bristle brush. Make sure you follow the contour of the snow when painting the shadows.

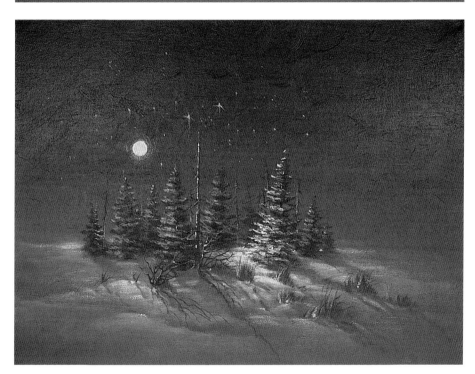

7 Add Highlights

Using a no. 4 round sable brush, highlight the edges of your trees with a thin sliver of a thick, opaque mixture of Titanium White (gesso) and a touch each of Cadmium Yellow Light and Cadmium Orange. Apply highlights with thick paint to make them stand out.

Painting Clouds

Clouds can be one of the most effective components in a landscape painting, but they also can be a compositional nightmare. It would be impossible to discuss all of the different types of cloud formations in these few pages. Instead I will teach you the basic techniques for painting clouds, which you can apply to any cloud formation you choose to paint.

Choose the proper type of cloud formation before you begin painting. Look at your overall composition and determine the focal point. From there, decide what type of cloud formation will work with that focal point. If the landscape is the focal point, keep the sky relatively simple. On the other hand, if you want the sky to be the focal point, keep the landscape simple to prevent competition between the two.

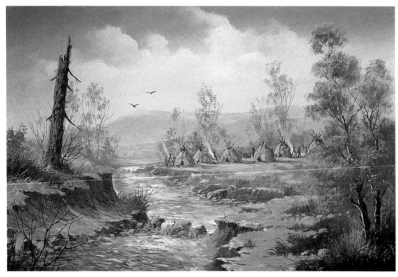

Clouds as Accents

The most common type of clouds are light clouds scattered throughout the sky over a darker blue or blue-gray background. These clouds have simple shapes, good composition and no shadows underneath them. Instead they blend into the background. Use this type of formation when the sky is not the feature and you want movement and interest that don't overpower the painting. It's a versatile type of formation that you probably will use often.

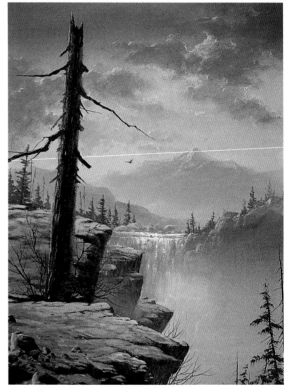

Clouds as Centers of Interest

These clouds form a more significant part—possibly the focal point—of the painting's composition. You can create tremendous effects with this type of cloud formation. There is an extreme contrast between light and dark values. You can apply a wide variety of color schemes to these clouds.

1 Underpaint Sky

Lay down a soft, medium-value background. Use a hake brush to apply a liberal coat of gesso over the entire area. While it is still wet, apply a small amount of Cadmium Orange at the horizon line and blend it up into the sky. Apply a blue-gray mixture of Ultramarine Blue and a touch each of Burnt Sienna and Dioxazine Purple, starting at the top and blending down until you blend the two tones together. The blue-gray mixture will appear dark until blended with the gesso.

2 Underpaint Clouds

Mix Titanium White (gesso) and a touch of Cadmium Orange as a light complement to the gray tone. Load the end of a no. 6 flat bristle brush with a small amount of the mixture and drybrush the cloud formations, carefully blending the bottom of each cloud into the background. Good composition is critical here; make sure you have good negative space. Once the paint has dried, you can repeat the step to brighten the clouds.

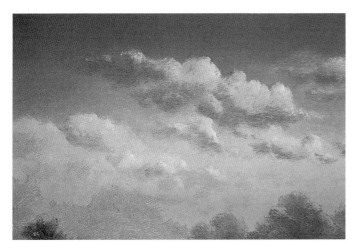

3 Add Shadows

Place a deeper, darker shadow under the clouds to give them definition and three-dimensional form and to suggest a stormy atmosphere. Notice the change in the mood. Create a soft gray mixture of Titanium White (gesso), Ultramarine Blue, a touch of Burnt Sienna and a touch of either Cadmium Red Light or Dioxazine Purple. Adjust the value to suit the mood and to fit other values in the painting. Use a no. 6 or no. 10 flat bristle brush to scrub in shadows at the base of each cloud. If necessary, thin the mixture slightly so it will blend more softly.

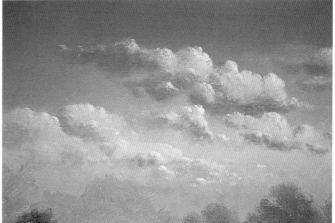

4 Add Highlights

You can add more highlights or values to create other layers of clouds to suggest depth.

Using Photography for Reference

Photography is a wonderful tool for gathering reference material. Paintings you create from your own photographs are your own, original, unique creations.

Let's take a look at the equipment. I'm not a professional photographer, but I've learned the necessary skills that apply to my work as a professional artist.

Camera and Lens

Most artists prefer a quality 35mm camera. The camera that works best for me is the Pentax P30 T with a Takumar-A Zoom 28mm to 80mm three-in-one lens.

I don't have to carry multiple lenses, and it's easy to operate and reasonably priced. I tend to damage lenses more often than I would like because I often use my camera in extreme conditions. Replacing this lens is easier on the checkbook.

This lens also has a macro, which takes extremely close-up shots, such as a lady bug on a leaf or a dew drop.

Film

Photography is much easier when you understand film speed. I like to paint from prints rather than slides, so I use regular film. I use 200-speed film as an all-purpose film because it works well for both overcast and sunny days. I use 100-speed film in normal sunlight. 400-speed film works for most lighting situations, but it works best for low-light situations, such as late evening. Keep film of all different speeds on hand.

Research

Now let's look at the research process: A painting starts with an idea. Once you've decided on a subject, a color scheme, values, a season and atmosphere, begin gathering reference material for these particular elements. I have a large collection of photographs on file, and I catalog them by subject. If I have exhausted my files and haven't found what I need, I grab my camera and head to the great outdoors to photograph the rest.

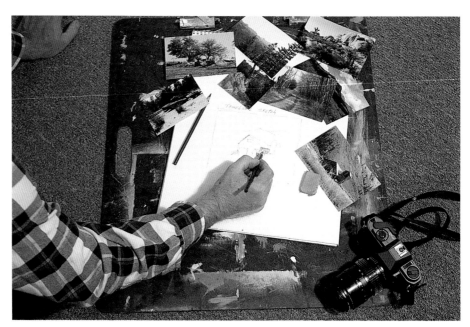

Sketch Pad and Reference Materials
Once I have gathered all of my reference materials, I spread them out in front of me with a sketch pad.

When I have gathered my reference materials, I make several thumbnail sketches of different compositions using combinations of several photos. For example, you may use a mountain from one photo, a tree from another, a lake or stream from another and a unique sky formation from another to make a composite sketch of these elements.

A good understanding of basic composition is very important when using reference photos. Artists don't generally copy their photos exactly. They use reference photos to get ideas, and then use artistic license to create your their own works of art.

Look at the following photographs. Each has different subjects I would like to include in my painting. I combined elements from each photo to create a composite sketch with good composition.

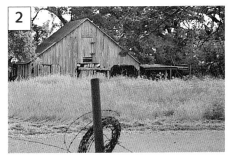
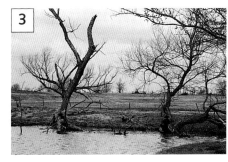
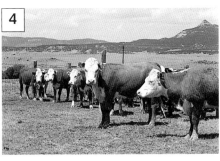
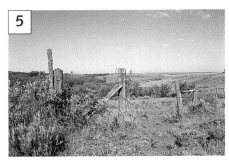
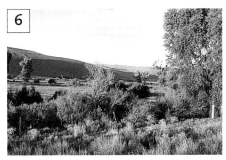

Reference photos

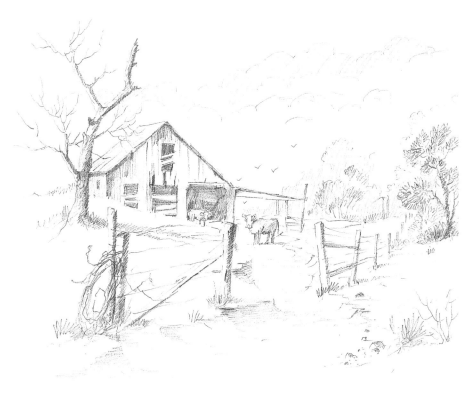

Composite Sketch

I combined the cloud formation from photo 1, the barn and wire from photo 2, the dead tree on the left from photo 3, some cows from photo 4, the fence post from photo 5 and miscellaneous landscape items from photo 6 to draw this sketch.

Your imagination plays a vital role in creating a good composite sketch. Even when you have reference photos for most of the objects, you will have to use your imagination for some things, such as rock formations, land contour, shadows and negative space for good eye flow. Color scheme, value and atmospheric conditions determine these factors as you compose the painting. Grab a bunch of photos and have fun composing your next painting!

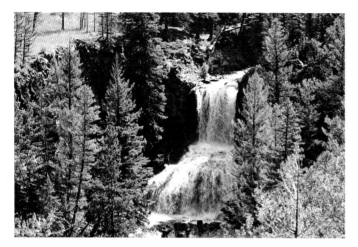

Reference photos

Thumbnail
I used the reference photos at left and the thumbnail sketch above to paint the final painting on page 39.

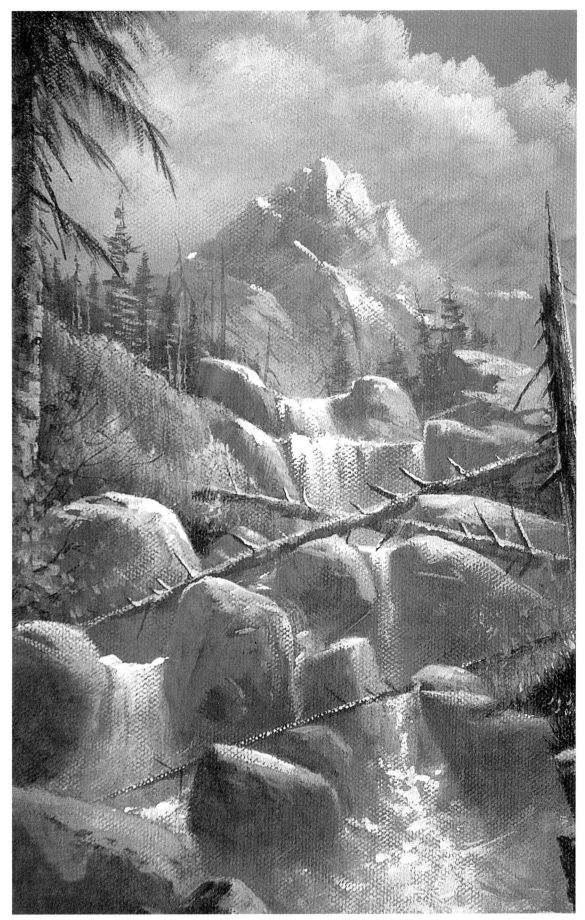

High Country Falls
12" × 24" (30cm × 61cm)

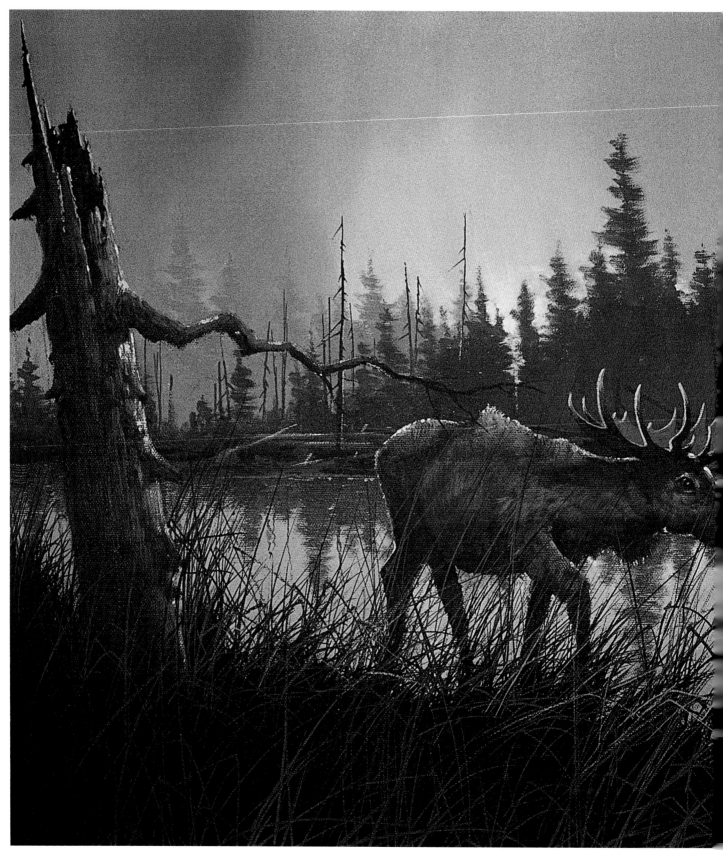

Giant of the Yellowstone
16" × 20" (41cm × 51cm)

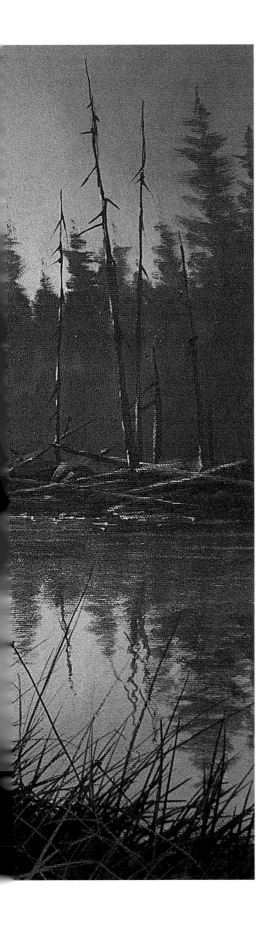

Giant of the Yellowstone

Every year in early May, the gates of Yellowstone National Park open for spring. I try to plan a workshop or research trip each year to study the wildlife and landscape. During one particular trip, a forest fire had been burning for several days. Smoke had settled in the forest and mixed with the fog, and a light mist was born. As the sun rose above the pine trees and tried to shine through the thickening haze, it created a unique, almost eerie color combination. As I sat on a log watching this phenomenon, a giant moose emerged from the mist and began grazing along the edge of the Madison River. I took several good photos. What a perfect subject and atmosphere for an instructional painting in this book! In this demonstration, you'll study a truly unique animal and have a great opportunity to practice drawing and painting a large animal.

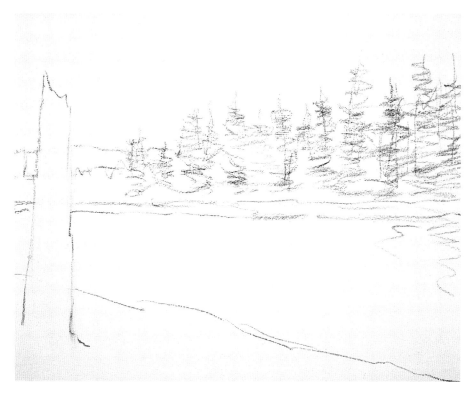

1 Draw Basic Sketch

Make a rough sketch of the basic components of the landscape with no. 2 soft vine charcoal. You don't really need to sketch in the moose yet.

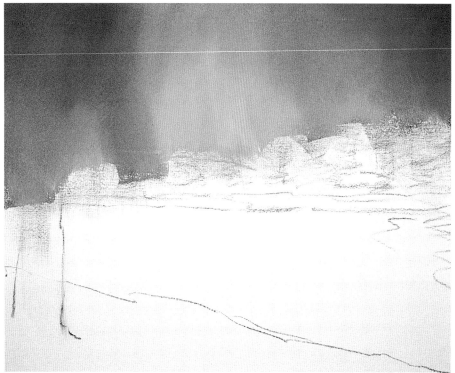

2 Paint Sky

Apply a liberal coat of gesso over the entire sky with a hake brush, making sure the paint is fairly creamy. While it is still wet, use slightly angled, vertical strokes to brush in Cadmium Yellow Light and Cadmium Orange over most of the sky. Apply Ultramarine Blue and touches of Burnt Sienna and Dioxazine Purple with long, vertical strokes, leaving irregular patterns of dark and light values. Notice how soft the blended edges are.

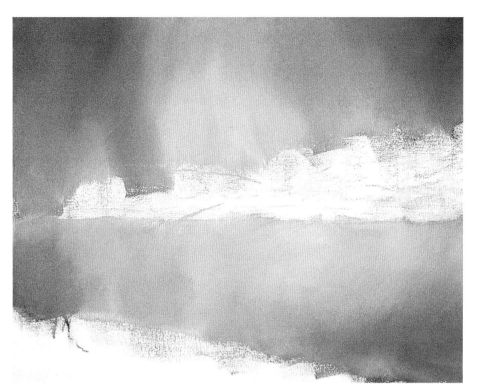

3 Underpaint Water

Follow the same process and use the same colors to underpaint the water. You'll add reflections later. Keep the blended edges soft.

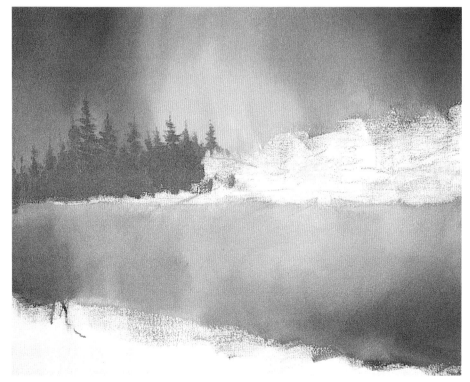

4 Paint Distant Pine Trees

This is the only element of the painting that will provide depth. Mix Titanium White (gesso), a touch of Dioxazine Purple, a touch of Burnt Sienna and a very slight touch of Ultramarine Blue, making the value slightly darker than the sky. Scrub in the basic shapes of the pine trees with this mixture and a no. 4 flat bristle brush. Notice how they almost blend into the background.

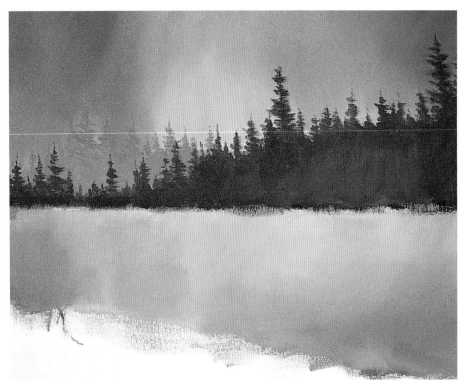

5 Paint Middleground Pine Trees

Mix a good-sized batch of Dioxazine Purple; touches of Cadmium Yellow Light, Burnt Sienna and Ultramarine Blue; and just a little Titanium White (gesso). Add just enough water to make the mixture fairly creamy. These trees have very little detail. They're very suggestive and actually impressionistic. Scrub in the pine trees with a no. 6 flat bristle brush. Use a variety of shapes and sizes and plenty of good negative space.

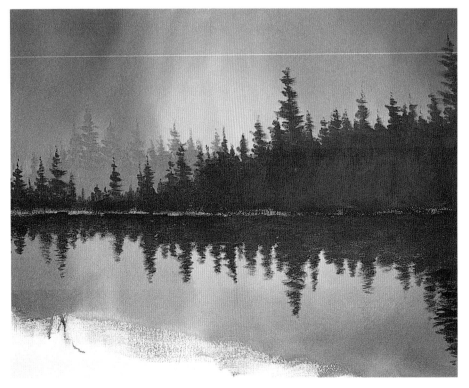

6 Paint Reflections

Even though this body of water is very calm, the reflections still should have a bit of a rippled edge simply to make the water appear wetter. Slightly lighten the mixture from step 5 with a little Titanium White (gesso). Scrub in the reflections with horizontal dry-brush strokes and a no. 6 flat bristle brush. You don't need to duplicate the pine trees exactly. Just make them similar.

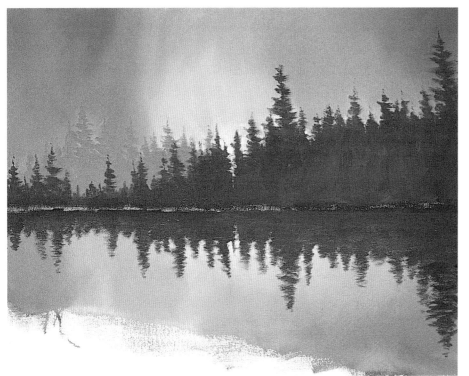

7 Add Sun's Glow

Add the strong backlighting behind the trees that really adds atmosphere to the painting. With very dry no. 4 and no. 6 flat bristle brushes, scrub in a mixture of Titanium White (gesso) and a little Cadmium Yellow Light behind the trees, in the sky and in the water. As you brush this color on, be sure to blend the edges into the background so there are no hard edges. You may need to repeat this step two or three times because you are using a dry-brush stroke.

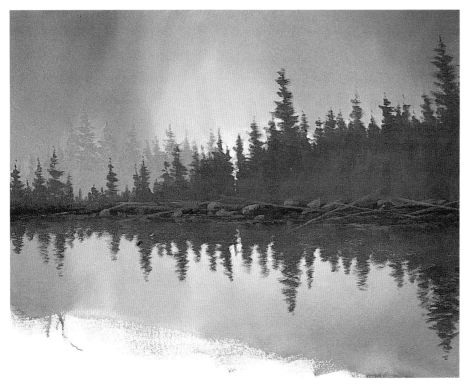

8 Paint Shoreline

Slightly darken the pine tree color. Then paint in some suggestions of irregularly shaped rocks, vegetation and a few fallen logs with a no. 4 or no. 6 flat sable. Don't be afraid to put in quite a bit of scattered debris along the shoreline. It will add authenticity to the painting. Add some subtle highlights to these forms with a mixture of Titanium White (gesso), a touch of Cadmium Orange and a touch of the pine tree color to make them appear a bit more three-dimensional. Just be careful not to overhighlight!

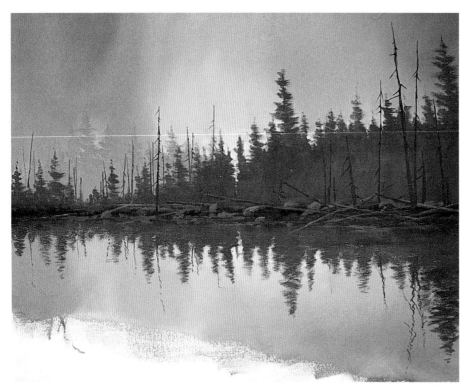

9 Add Dead Trees

Darken the pine tree mixture from step 5 to make two new values—one for the distant tree trunks and a darker value for the dead trees on the bank. Make the mixtures very creamy. Add a nice collection of trees of different shapes and sizes in the background and along the shoreline with a no. 4 round sable or no. 4 script liner.

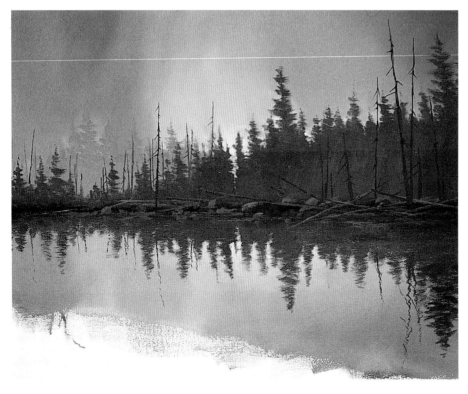

10 Glaze Water

Load a hake brush evenly across the chisel edge with a thin glaze of water and a bit of gesso. Holding the brush perpendicular to the canvas, drag it across the surface of the water. You can create a ripple effect by wiggling the brush as you drag it.

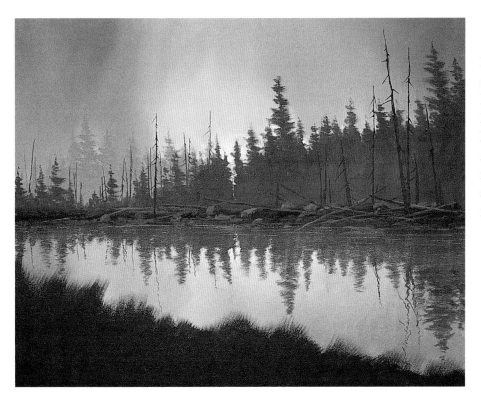

11 Underpaint Foreground Grass

Darken the pine tree mixture from step 5 with more Ultramarine Blue, Burnt Sienna and a little Dioxazine Purple. You can add a touch of Hooker's Green Hue to this mixture if you wish. Paint in a nice, opaque foreground against the water with a soft, irregular edge using a no. 10 flat bristle brush.

12 Underpaint Dead Tree

Block in the stump with a no. 6 flat bristle brush and a mixture of Burnt Sienna, Ultramarine Blue and a touch of Dioxazine Purple. Be sure to cover the canvas well.

13 Sketch Moose

Sketch in the moose with no. 2 soft vine charcoal. If you need to practice, sketch it on a piece of paper first and then transfer it to the canvas.

14 Underpaint Moose

Block in the entire body of the moose with a no. 4 flat sable brush and a mixture of Ultramarine Blue and Burnt Sienna. Change the value slightly with Titanium White (gesso) when needed. Keep your edges soft here.

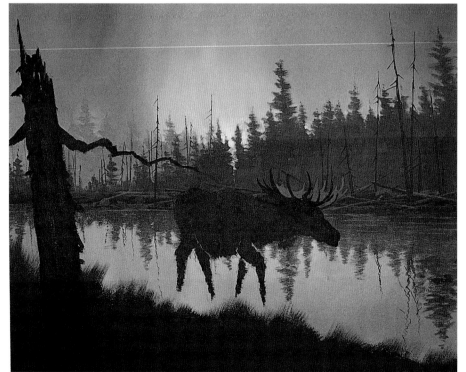

15 Highlight Stump

Add Titanium White (gesso) and Cadmium Orange to the original stump mixture to create a nice, soft midtone highlight. Use short, choppy, vertical strokes with a no. 4 flat sable brush to suggest weathered wood or bark. Let the highlight fade into the base color as you move around the tree until the tree looks round. You'll add brighter highlights later.

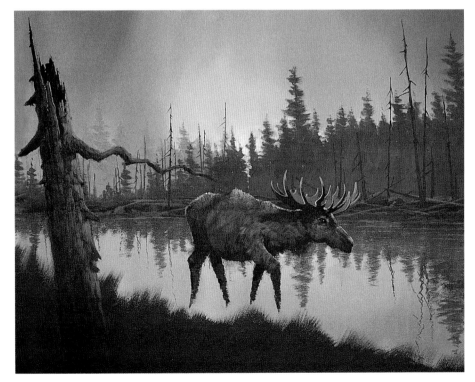

16 Add Details to Moose

Refer to the tips for painting fur on page 25 before you begin this step. Make a creamy mixture of Titanium White (gesso) and touches of Cadmium Orange, Cadmium Yellow Light, Ultramarine Blue and Burnt Sienna to slightly gray the mixture. Load just a little of the mixture on the end of a no. 4 flat sable brush and, beginning at the top of the moose's body, use short dry-brush, feathery strokes to follow the contour of the body. Allow some of the underpainting to come through so the hair will have a little depth to it. We'll add final highlights later. If you make a mistake, paint over the area with the base color and repeat this step.

17 Add Foreground Grass

Really loosen up on this step. Roll a no. 4 script liner in an inky mixture of Ultramarine Blue, Burnt Sienna, a touch of Dioxazine Purple and, if you wish, a little Hooker's Green Hue until the brush comes to a point. Put in a variety of overlapping weeds. Don't be afraid to put in a lot. It makes the grass look wild and realistic.

18 Highlight Grass

For this step, change the value of the mixture you used in step 17, adding a lot more Titanium White (gesso) and touches of Cadmium Yellow Light and Cadmium Orange. Make sure the mixture is very inky, and, using a no. 4 script liner, cover the underpainting with a variety of shapes, sizes and lengths. Add plenty of overlapping, bent and angled weeds. Don't hesitate to add variety by changing the value or color with a little more Cadmium Yellow Light or Cadmium Orange.

19 Add Final Details

Give the painting a little sparkle. Use one basic highlight color for this step. Using a no. 4 round sable brush, apply a silver lining—a mixture of Titanium White (gesso) and a touch of Cadmium Yellow Light and/or Cadmium Orange—on the edges of the main objects, such as the dead pine trees, the stump, the moose and the moose's antlers. Apply these highlights with opaque layers so they will stay nice and bright.

This painting probably challenged you, but paintings like this can really help build your confidence, so keep up the good work!

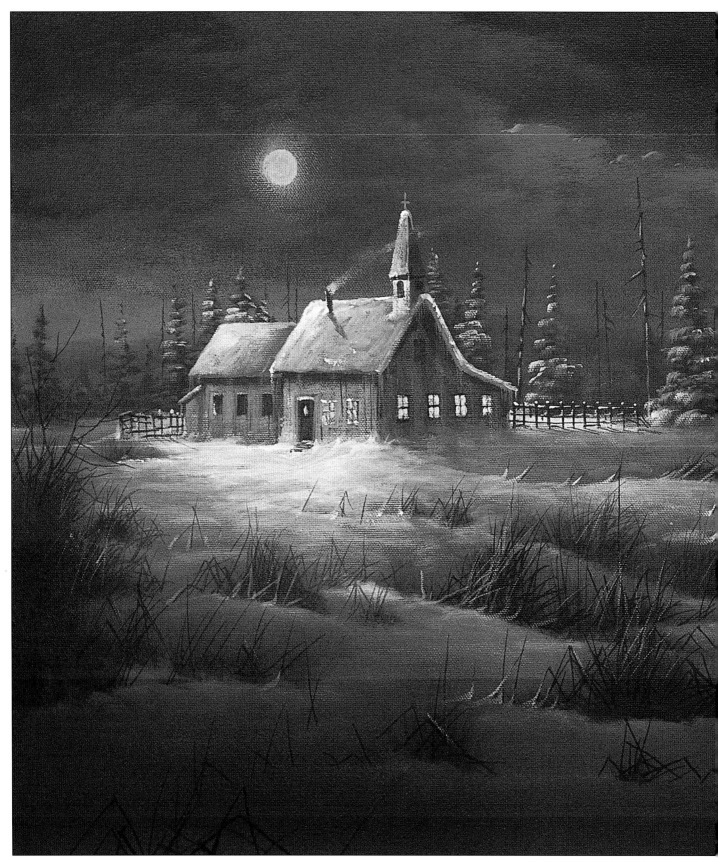

Evening Prayers
16" × 20" (41cm × 51cm)

Evening Prayers

By now you know that I love painting winter scenes and especially snow. In this painting, though, I want to teach you how to paint night scenes. Refer to the list of characteristics of night scenes on page 30. This painting provides a great opportunity to work on contrast, the key component of night scenes. It also allows you to work on atmosphere—in this case a cold, crisp night. The warm light from the windows and the cast shadows on the snow add to the interest and the feeling of the snowy night scene. You get a warm feeling when you look at this painting, even though the scene is of a cold night. The smoke from the chimney and the soft glow from the windows make this building an inviting place to spend a long, winter evening. Join me and you will learn a lot from this painting.

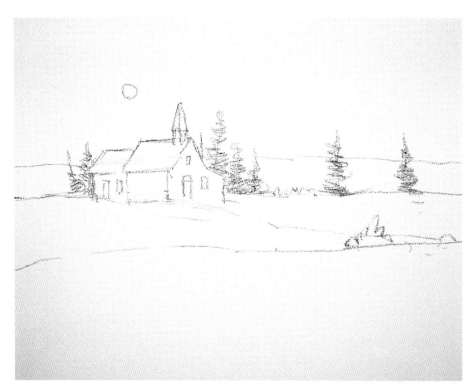

1 Draw Basic Sketch

There is not much detail to this sketch. It serves only to help you see where everything should go, so keep it simple.

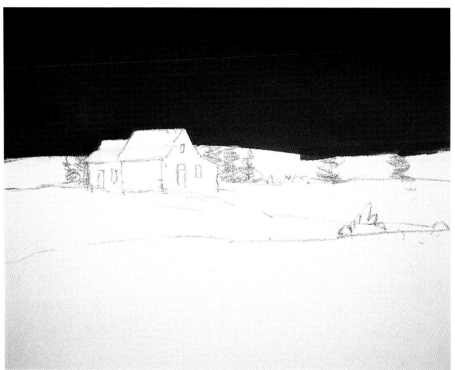

2 Underpaint Sky

This is a great color scheme. Lightly wet the sky and then apply an even coat of gesso with a hake brush. While it is still wet, apply Ultramarine Blue and Burnt Sienna. Mix these on the canvas instead of your palette. Mix them together all over the sky until you have a nice, rich, dark gray. Then mix in a little Dioxazine Purple to add a snowy atmosphere.

3 Drybrush Clouds

Scrub in some cloud masses with a no. 10 flat bristle brush and a mixture of Ultramarine Blue, Burnt Sienna, a little Titanium White (gesso) and a touch of Alizarin Crimson to create a soft, midtone gray. Scatter the clouds throughout the sky, keeping the edges soft. Don't make the clouds too bright. You just need enough contrast to make the clouds stand out from the background.

4 Paint Background Hill

Add just enough Titanium White (gesso) to a mixture of Ultramarine Blue and touches of Burnt Sienna and Dioxazine Purple to lighten the value so it is just slightly darker than the sky. Scrub in the soft range of hills with a no. 6 flat bristle brush. Notice that they almost fade into the background.

5 Paint Background Pine Trees

These pine trees are slightly darker than the background hills, so add just a little Dioxazine Purple and a touch of Hooker's Green Hue to the mixture from step 4. Paint in these trees with a no. 4 flat bristle brush. You don't need any detail here; just suggest the forms. Also make sure you have good negative space around the trees.

6 Underpaint Snow

Make a mixture of Ultramarine Blue, touches of Burnt Sienna and Dioxazine Purple and just enough Titanium White (gesso) to make a rich, purple gray. Underpaint the entire foreground with a no. 10 flat bristle brush. Make sure you cover the canvas well.

7 Add Snow to Pine Trees

Dab snow on the pine trees to give them form with a no. 4 flat sable brush and a bluish gray mixture of Titanium White (gesso), touches of Ultramarine Blue and Dioxazine Purple and a little Burnt Sienna. Don't overpaint or the trees will lose their forms.

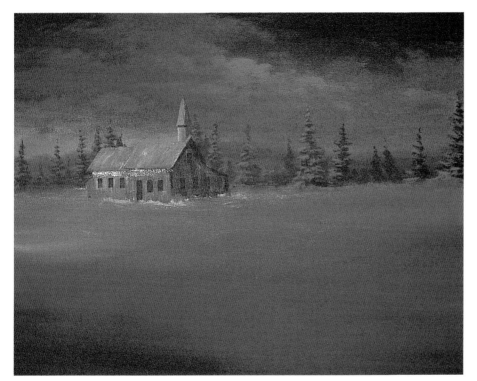

8 Underpaint Church

You'll establish the basic values of the church in this step. Block in the dark side with a no. 4 flat bristle brush and a mixture of Burnt Sienna, touches of Ultramarine Blue and Dioxazine Purple and just enough Titanium White (gesso) to gray the mixture. Add a little more Titanium White (gesso) to the mixture and block in the light side of the building. Add even more Titanium White (gesso) and a little more Dioxazine Purple and block in the roof, door, windows, steeple and soft shadow from the roof's overhang.

9 Highlight Snow

Dry-brush in the highlights to give the snow its contour with a no. 6 flat bristle brush and a mixture of Titanium White (gesso), a touch of Cadmium Orange and just a touch of Ultramarine Blue to gray it. Leave pockets of negative space to create depressions in the snow. You'll add grass and bushes here later. Also paint the rest of the shadows from the roof's overhang.

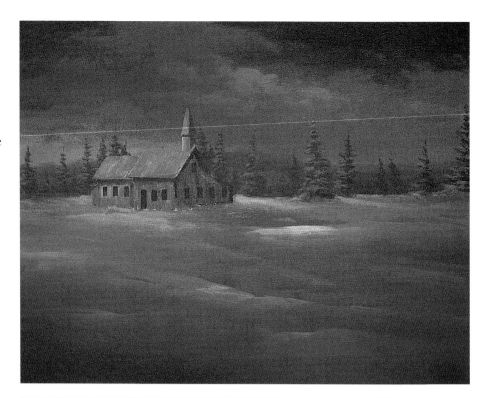

10 Block In Clumps of Grass

Drybrush in clumps of grass with a no. 10 flat bristle brush and a fairly creamy mixture of Burnt Sienna and a touch of Dioxazine Purple. The clumps should fit nicely into the depressions you created in step 9. Overlap some of the clumps to create good negative space.

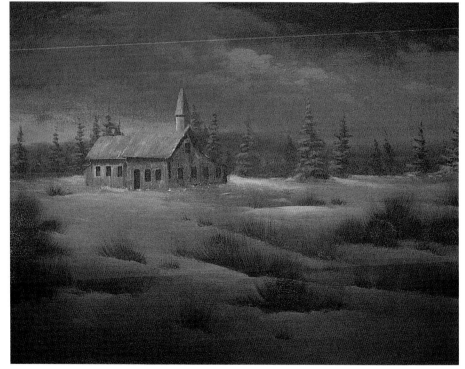

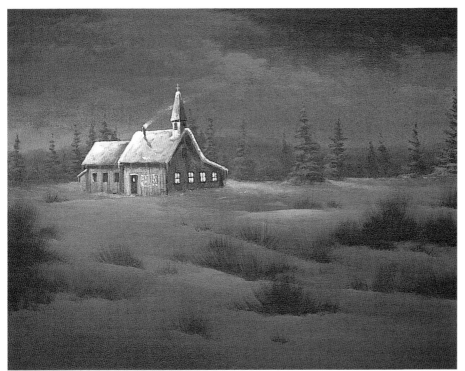

11 Add Details to Church

Paint the snow on the roof and the side of the steeple with a no. 4 flat sable brush and a mixture of Titanium White (gesso) and a slight touch of Cadmium Yellow Light. Drybrush a little of this color onto the front of the church to give it a little more light. Dab in the light in the windows with a mixture of Cadmium Yellow Light and a touch of Cadmium Orange. Add any other details you wish, such as a chimney with smoke coming out of it, icicles dripping from the corners of the roof, windowpanes, a cross on the top of the steeple, etc.

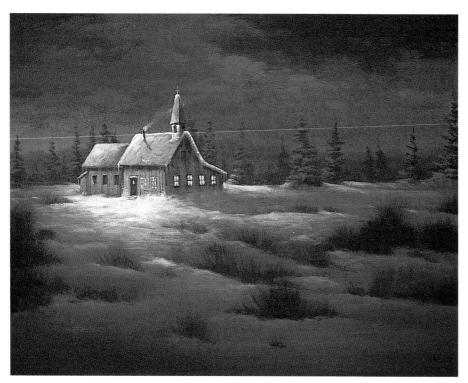

12 **Add More Snow Highlights**
Highlight the tops of the snowdrifts in the middleground and background with a no. 4 flat bristle brush and a mixture of Titanium White (gesso) and a touch of Cadmium Yellow Light. Don't put too many highlights in the foreground, but don't be afraid to add some brighter patches of snow, such as in front of the church. Just make sure your value system stays balanced. Blend carefully, making sure to leave no hard edges.

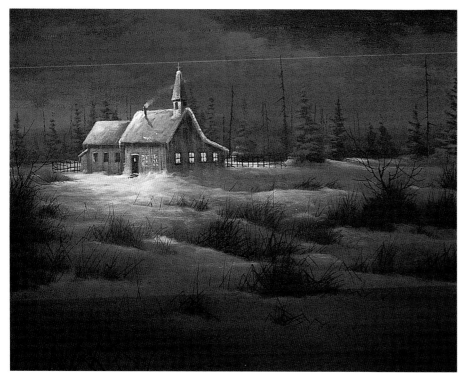

13 **Add Miscellaneous Details**
Really have fun with this step. Add the taller weeds throughout the clumps of grass with a no. 4 script liner and an inky mixture of Ultramarine Blue and Burnt Sienna. At the same time, add miscellaneous dead bushes to act as eye stoppers on each side of the scene. Add the fence and the dead pine trees in the background. Add any other details that you'd like to the church as well.

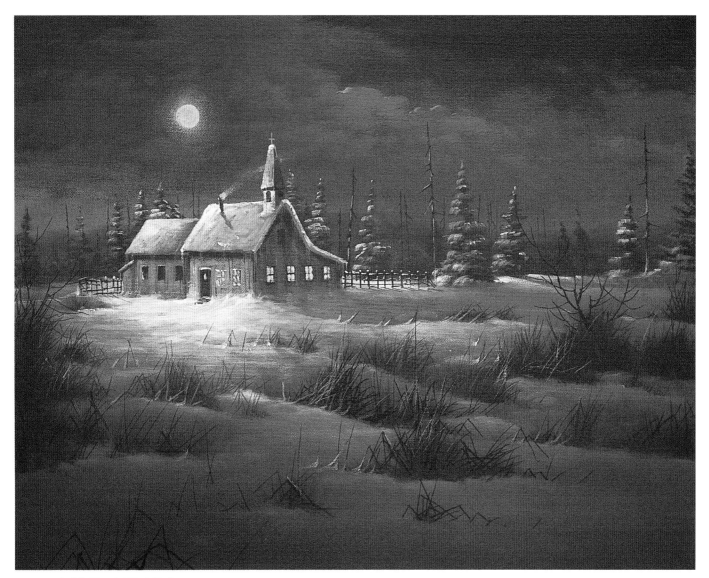

14 Add Final Highlights

Dab in highlights on the pine trees and block in the moon with a no. 4 flat sable brush and a mixture of Titanium White (gesso) and a touch of Cadmium Yellow Light. Drift snow up against the weeds with a no. 4 round sable brush and the same mixture to accent them. Add a few highlights to the top of the roof, the fence and some of the dead pine trees. Keep most of the light in the middle background surrounding the church, though. Dry-brush some of the highlight color around the edge of the moon, carefully blending into the background.

This was an exciting painting and a great learning experience. It also can make a great winter holiday card. Keep up the good work. I look forward to working with you on our next painting adventure.

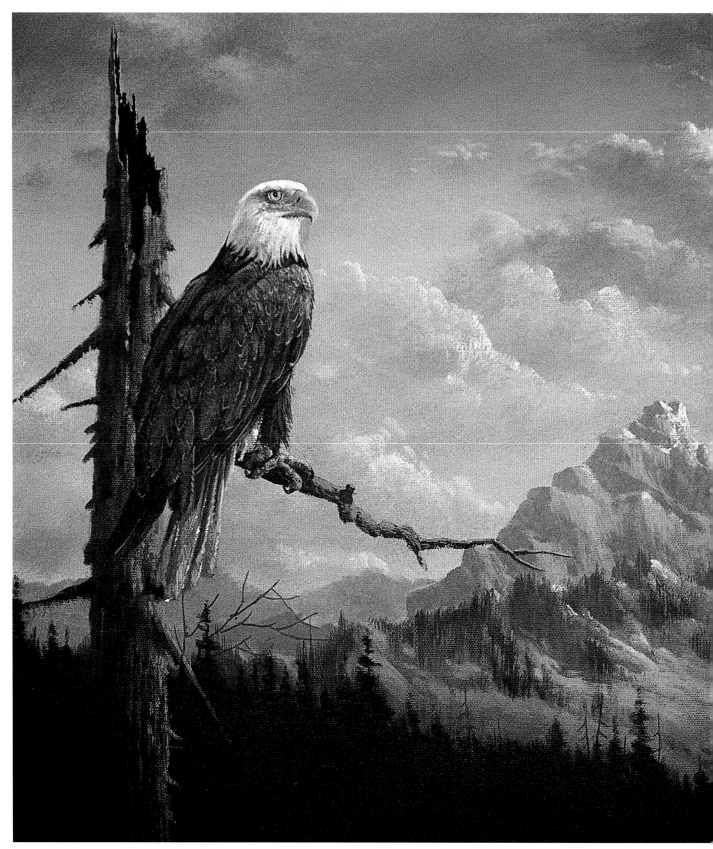

The Guardian
16" × 20" (41cm × 51cm)

The Guardian

Just the thought of painting a large bird of prey and all the feather details scares most people. But I've simplified the eagle's form and adjusted the details to make it simpler for you. I've been studying birds for many years and have spent endless hours photographing, sketching and illustrating these phenomenal creatures. Just relax and enjoy the learning process. This painting is about not only the eagle, but also the wonderful mountain range, the great cloud formation and the dead pine tree that the eagle is perching on. Practice will help perfect your technique. You may end up painting the eagle over two or three times, but the experience and the result will be worth it. This is a fun painting, and your confidence will be sky-high when you finish it.

1 Draw Basic Sketch

Once again, make a rough sketch of the main composition with no. 2 soft vine charcoal. Even though you'll paint over it, the sketch helps you picture the painting on your canvas.

2 Underpaint Sky

Lightly wet the sky, then apply a liberal coat of gesso with a hake brush. Starting at the horizon, blend Cadmium Yellow Light and Cadmium Red Light halfway up while the gesso is still wet. Add Ultramarine Blue and a little Burnt Sienna at the top of the canvas and blend downward until you meet the horizon color. Carefully blend over the horizon color until you create a fairly dusty color in the middle of the sky. Keep all blended edges soft, and make sure you have a variety of subtle color changes.

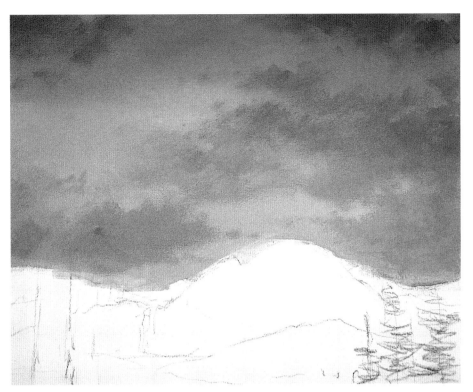

3 Underpaint Clouds

Create a soft gray mixture of Titanium White (gesso), Ultramarine Blue, a touch of Burnt Sienna and a touch of Cadmium Red Light. Scrub in the shadowed part of the cloud formations with this mixture and a no. 6 flat bristle brush. You may need to make the mixture slightly creamy, but make absolutely sure all of the cloud edges are soft.

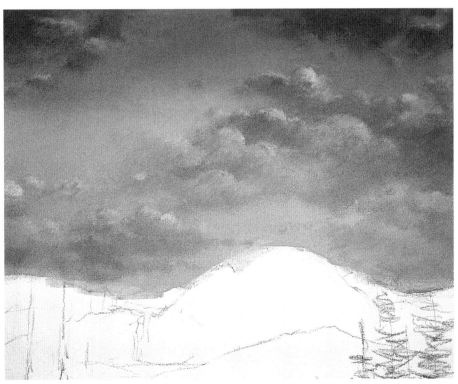

4 Paint Tops of Clouds

Scrub in the tops of the cloud formations with no. 4 and no. 6 flat bristle brushes and a fairly creamy mixture of Titanium White (gesso) and a touch of Cadmium Orange. Notice the good negative space around the clouds and the depth created by overlapping them.

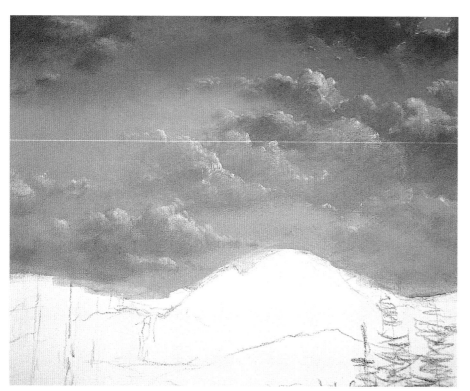

5 Highlight Clouds

Be a little more careful and a bit more precise in this step. Add a little more Titanium White (gesso) and a touch of Cadmium Yellow Light to the mixture you used in step 4. Carefully highlight the very tops of the clouds with this new mixture and a no. 4 flat sable brush. Don't apply too many highlights, but make sure the paint is opaque so it stays nice and bright.

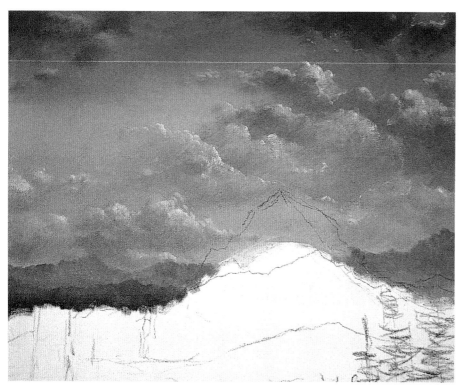

6 Underpaint Background Mountains

Redraw the sketch lines for the large mountain that you painted over in step 2. Make a mixture of Titanium White (gesso), touches of Ultramarine Blue and Burnt Sienna and a little Dioxazine Purple. Make sure the value is slightly darker than the blue part of the sky. Scrub in the first range of distant mountains with this mixture and a no. 6 flat bristle brush, keeping the mountain range simple and soft.

7 Underpaint Large Mountains

The mountain is a major feature in this painting, but it still is in the distance, so you don't want to make it too dark. Make a mixture of Titanium White (gesso), Ultramarine Blue and touches of Burnt Sienna and Dioxazine Purple, adjusting the value so it is slightly darker than the background mountain. Block in the mountain with this mixture and a no. 6 flat bristle brush, making sure you have some unique shapes along the edges. These will come in handy when you add highlights.

8 Highlight Large Mountains

After the paint dries, wipe off any charcoal lines from the top of the large mountain that you did not paint over in the last step. Make a fairly creamy mixture of Titanium White (gesso) and a touch of Cadmium Orange for the highlights. Add highlights to the mountain with a no. 4 flat sable brush, beginning at the top and using short, choppy dry-brush strokes. Don't put too much paint on your brush or the highlights will be too bright. If you need to increase the brightness, just repeat the strokes.

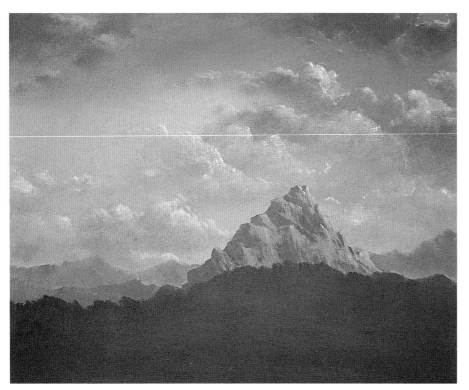

9 Underpaint Middleground Mountains

This step is a bit challenging. Make a grayish green mixture of Titanium White (gesso), Burnt Sienna, Ultramarine Blue and touches of Dioxazine Purple and Hooker's Green Hue. Make the value slightly darker than the value of the large mountain. Dab in suggestive forms of pine trees across the top of the mountain with this mixture and a no. 4 flat bristle brush held perpendicular to the canvas. Change the color and darken the value of the mixture by adding a little more Dioxazine Purple and Titanium White (gesso). Block in the rest of the mountain using short, choppy strokes to suggest rocky ground.

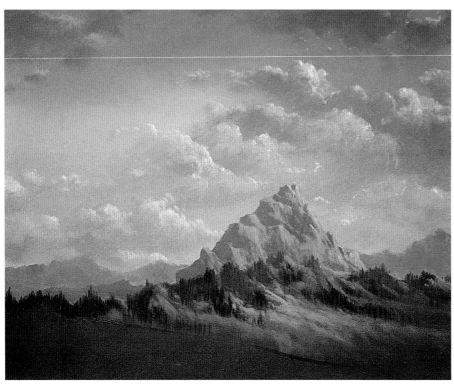

10 Add Details to Middleground Mountains

Add more Titanium White (gesso) and a touch of Cadmium Orange to the first mixture from step 9 to create a soft highlight color. Suggest rugged, rocky ground formations with a no. 4 flat bristle brush. Let some of the background color show through to add three-dimensional form to the rock formations. You'll add final highlights later.

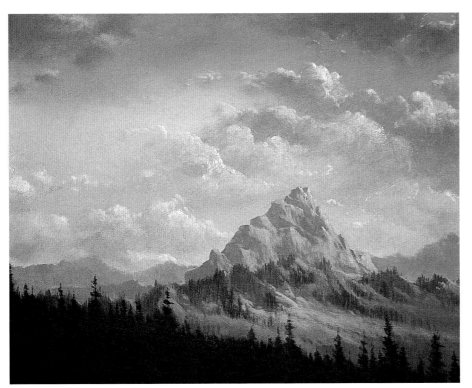

11 Underpaint Foreground Pine Trees

Make sure you use good negative space around the pine trees in this step. Fill in the entire foreground with a nice, rich, greenish gray mixture of Hooker's Green Hue, Burnt Sienna and a touch of Dioxazine Purple. I used a no. 6 flat bristle brush, but you may feel more comfortable with a no. 4 flat bristle. Carefully place the pine trees to create a path for the eye to follow. Notice that the trees are not detailed but just suggested with fairly soft edges.

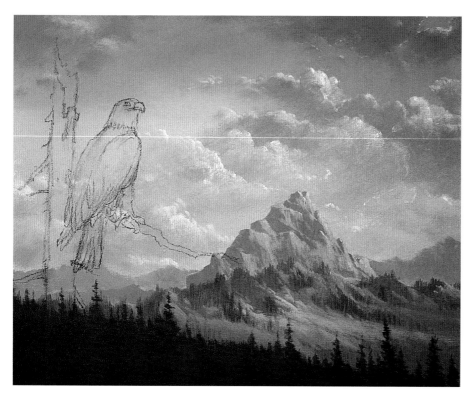

12 Sketch Tree and Eagle

You don't normally need a very accurate sketch for landscapes, but you do for this eagle. You can use a soft charcoal pencil instead of no. 2 soft vine charcoal if you want a sharper point. When the paint from step 11 is dry, sketch the tree and eagle lightly.

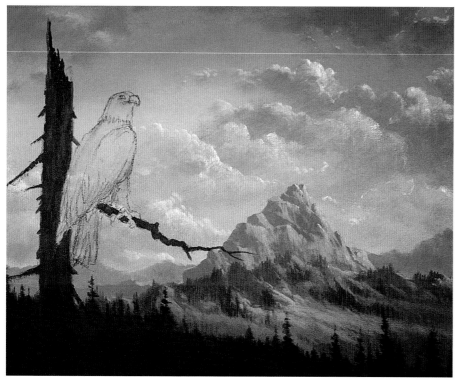

13 Underpaint Dead Pine Tree

With a no. 6 flat bristle brush, blend Ultramarine Blue, Burnt Sienna and a little Dioxazine Purple together on the stump, not on the palette. Use short, choppy, vertical strokes to create texture. Make sure no canvas shows through.

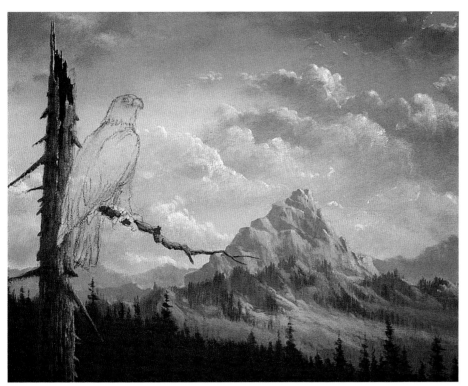

14 Add Details to Dead Tree

Make a fairly creamy mixture of Titanium White (gesso) and touches of Cadmium Orange and Burnt Sienna. Apply this mixture with a no. 4 flat sable and short, choppy, vertical strokes, beginning on the right and gradually working across to the dark side of the tree. Leave some dark areas showing through to create depth in the bark. With a mixture of Titanium White (gesso) and touches of Ultramarine Blue and Dioxazine Purple, drybrush the reflected highlights on the left side of the tree to make it appear rounder. Add some darker areas to suggest cracks and holes in the bark. You'll add final highlights later.

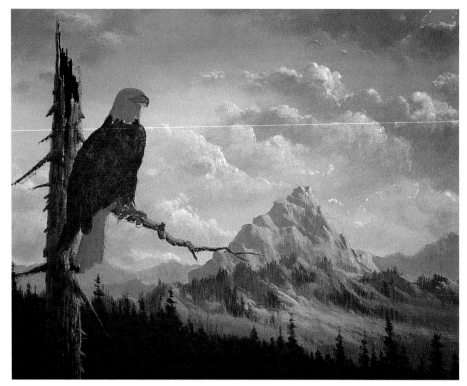

15 Underpaint Eagle

Make a mixture of Burnt Sienna and Ultramarine Blue for the dark body and a gray mixture of Titanium White (gesso), touches of Ultramarine Blue and Dioxazine Purple and a little Burnt Sienna for the head and tail. Block in these areas with a no. 4 flat sable brush. Don't create a hard outline, but make sure you cover the canvas. Add a little Cadmium Orange to the gray mixture and block in the beak and talons.

16 Add Details to Eagle

Practice this step on a scrap canvas before trying it on this painting. Make a creamy, light tan mixture of Titanium White (gesso), Burnt Sienna and a slight touch of Ultramarine Blue. Load just a little of this mixture on the end of a no. 4 flat sable brush and drybrush suggestions of feathers. Start at the bottom and work your way up. Leave some dark spaces between brushstrokes to separate the feathers. Don't block out all of the underpainting or you'll lose depth. Use the same technique and the same brush with pure Titanium White (gesso) for the head and tail. Repeat these strokes two or three times to create brighter highlights if you wish. Highlight the beak, talons and eye with a no. 4 round sable and a mixture of Cadmium Orange, touches of Cadmium Yellow Light and Titanium White (gesso). Add Ultramarine Blue and Burnt Sienna to the mixture for any really dark areas, such as the shadow underneath the beak. With a no. 4 script liner, put a few thin accent highlights on the edges of some of the feathers with a little Titanium White (gesso) and Cadmium Orange.

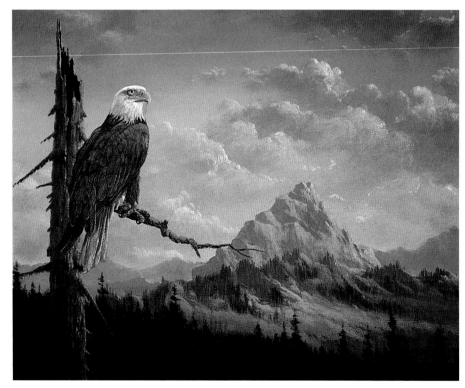

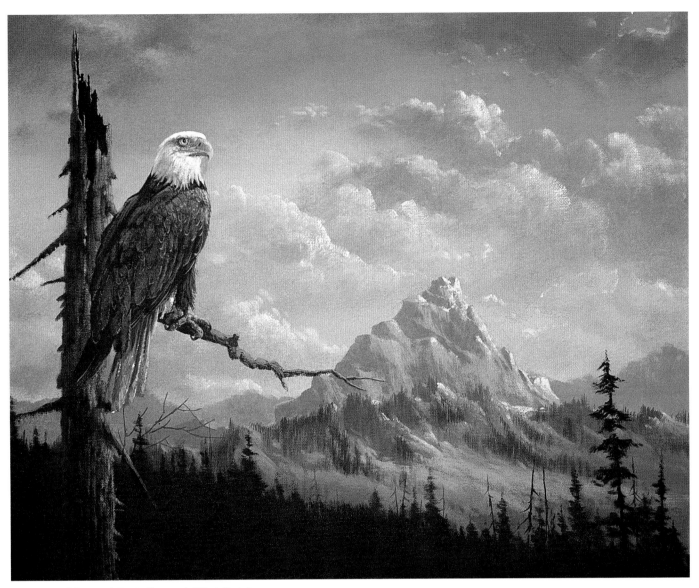

17 Add Final Details and Highlights

This step differs for each artist. If you're happy with the highlights and details, you don't need to do much now. I used no. 4 flat and round sable brushes for this step. I highlighted the large mountain with a mixture of Cadmium Orange and Titanium White (gesso). I highlighted the middle-ground pine trees with a mixture of Hooker's Green Hue and Titanium White (gesso). I highlighted the rock formations in the middleground with a mixture of Titanium White (gesso), Cadmium Yellow Light and Cadmium Orange. I added some dark pine trees in the foreground to serve as eye stoppers with a mixture of Hooker's Green Hue and Dioxazine Purple. I added a few light bushes at the base of the dead pine tree and a few brighter highlights on the eagle and dead pine tree.

This painting probably challenged you a bit more than the others, but what a terrific learning experience it was! Don't hesitate to try this one again. The results will improve each time, so keep up the good work!

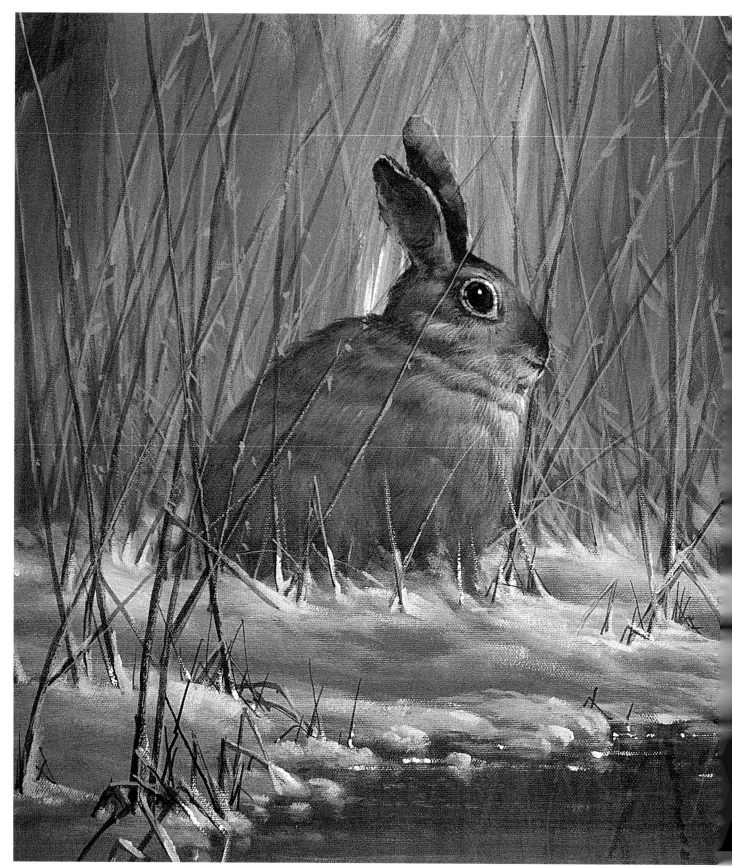

The Silent One
16" × 20" (41cm × 51cm)

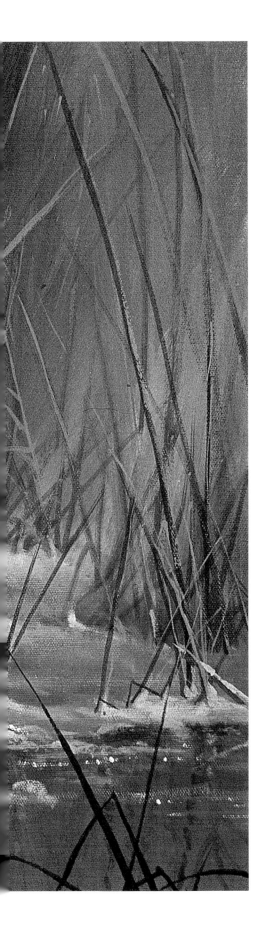

The Silent One

This painting brings back many memories from the beginning of my art career. I did a painting similar to this almost twenty years ago as a study of fur. A rabbit like this is an excellent study because there are not a lot of complicated body parts and angles to take your attention away from the fur. It turned out to be one of my most popular paintings, so I turned it into a limited edition print and it became a best-seller. If you have an interest in wildlife art and want to begin showing and selling it, start with small animals, such as rabbits, squirrels and chipmunks. They are fairly easy to paint and sell very well. This painting will help you get a handle on brush control—pressure, paint thickness, angle of the brush and dry-brush strokes—things that are critical to painting good fur. There are some bonus lessons here as well. Painting weeds, especially close, tall ones like these, is great fun and extremely challenging. Notice what a great addition to the atmosphere they are.

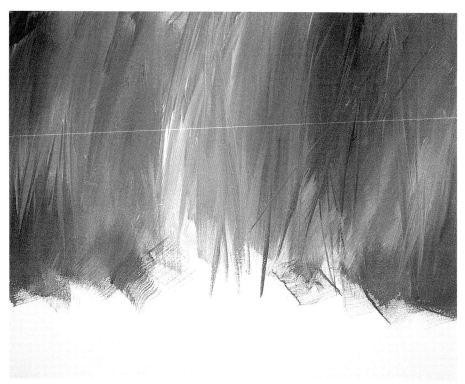

1 Paint Background

Have fun with this step. Lightly wet the background, and then paint on a liberal coat of gesso with a hake brush. While the gesso is still wet, add Ultramarine Blue, Burnt Sienna, Cadmium Yellow Light, Cadmium Orange, Dioxazine Purple, Cadmium Red Light and a little Hooker's Green Hue in long, vertical, slightly overlapping strokes. Don't blend these colors on your palette. Just put them on the canvas in any order and slightly blend the lines together for a gradated look.

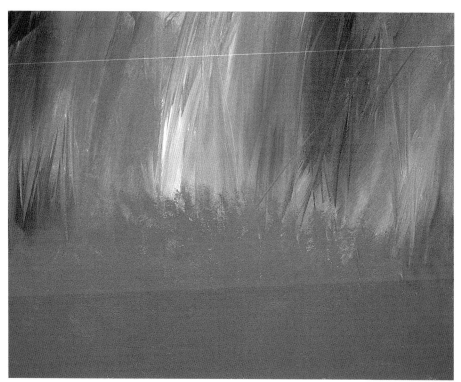

2 Underpaint Snow

Underpaint the rest of the canvas with a no. 10 flat bristle brush and a nice, midtone, purplish gray mixture of Titanium White (gesso), Ultramarine Blue and touches of Burnt Sienna and Dioxazine Purple. Make sure you have a fairly soft edge where the underpainting meets the vertical background strokes.

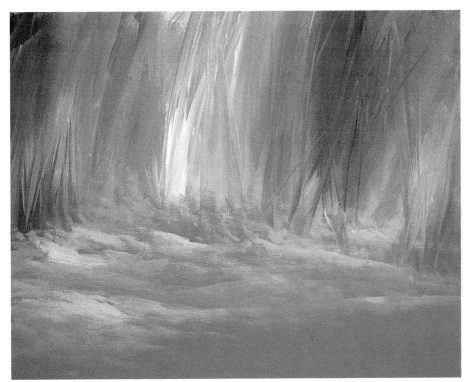

3 Highlight Snow

Give the snow some interesting contour and softness. Don't make this layer too bright because you'll add final highlights later. Drybrush in the basic contour of the snow with a no. 6 flat bristle brush and a creamy mixture of Titanium White (gesso) and a touch of Cadmium Orange. Make the blended edges very soft.

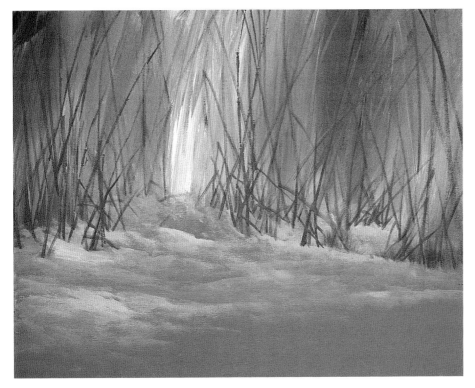

4 Paint Large Background Weeds

The weeds in this painting come in a good variety of sizes, shapes and angles. Make a base color of Burnt Sienna, Titanium White (gesso), Ultramarine Blue, a touch of Dioxazine Purple and a little Hooker's Green Hue. Thin this mixture substantially, and paint in these tall weeds, switching among a no. 4 flat sable, a no. 4 round sable and a no. 4 script liner. Occasionally change the value—by adding a little Titanium White (gesso)—and the color of the mixture.

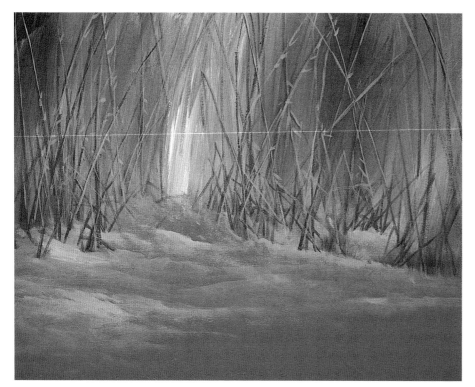

5 Highlight Background Weeds
Using the same techniques and any or all of the brushes you used in step 4, paint in some light-colored weeds with a fairly thin mixture of Titanium White (gesso) and touches of Cadmium Orange and Cadmium Yellow Light. Leave some weeds unhighlighted and paint new weeds with this highlight mixture to add depth and variety.

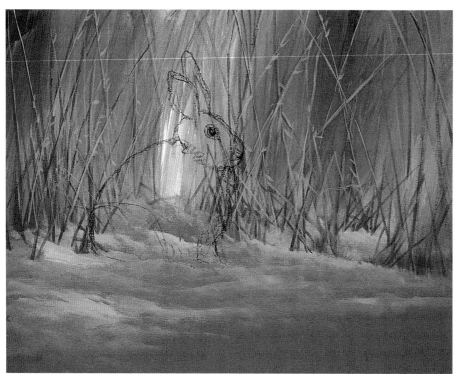

6 Sketch Rabbit
Make an accurate sketch of the basic shape of the rabbit, but don't worry about detail. If you need to work out the shape before drawing over your painting, sketch the rabbit on a sketch pad, and then transfer the drawing onto the canvas with graphite paper and a tracing pencil.

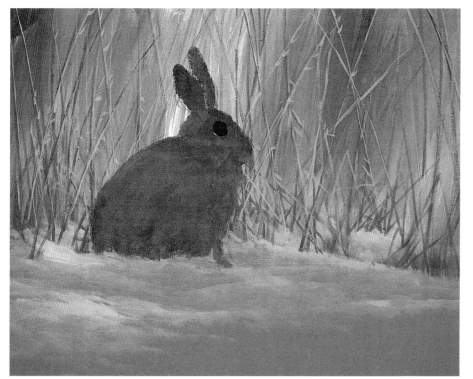

7 Underpaint Rabbit

Underpaint the rabbit with a no. 6 or no. 4 flat bristle brush and a fairly creamy mixture of Burnt Sienna and Ultramarine Blue. Don't paint a hard edge for the outline of the rabbit. Keep the edges slightly fuzzy so you will be able to paint over it when you paint the fur in step 8.

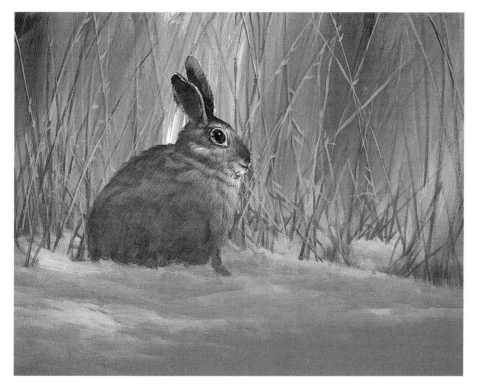

8 Add Details to Rabbit

Let's get down to business! Block in the eye, nose and dark areas on the ears with a no. 4 flat sable and a black mixture of Burnt Sienna, Ultramarine Blue and a touch of Dioxazine Purple. Load the very end of a no. 4 flat bristle brush with a small amount of a creamy mixture of Titanium White (gesso), a touch of Cadmium Orange and a touch of Ultramarine Blue to gray it. Dry-brush the fur on the rabbit, beginning at its base. Follow the contour of the body and let some of the underpainting show through to create depth within the fur. Switch to your no. 4 flat sable to finish the head and ears.

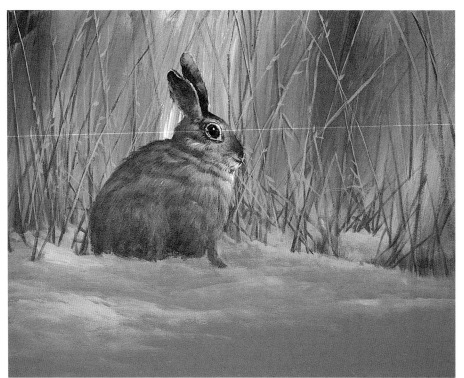

9 Highlight Rabbit

Add a lot more Titanium White (gesso) to the highlight mixture from step 8. With this new mixture and a no. 4 flat sable brush, add accents to the areas around the eye, cheek, neck and anywhere else you want to indicate a more three-dimensional effect. Drybrush the brighter highlight on the front of the rabbit with a no. 4 round sable brush and creamy, pure Titanium White (gesso). Paint a rim around the eye, making sure it is slightly broken. Add the highlight in the pupil with a no. 4 round sable, and you've got a rabbit!

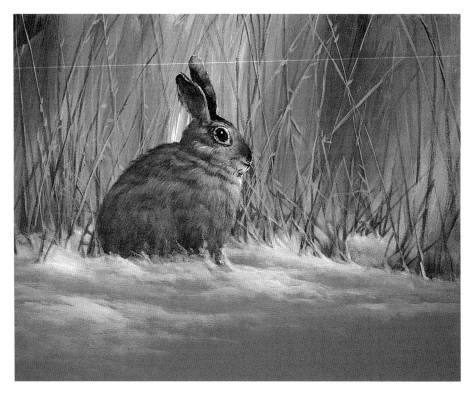

10 Drift Snow on Rabbit and Weeds

Settle the weeds and rabbit down so they don't look like they're floating. Drift the snow up against the rabbit and all of the weeds you can reach with a no. 4 flat sable brush and a very creamy mixture of Titanium White (gesso) and small amounts of Cadmium Yellow Light and Cadmium Orange. Blend the snow out into the original underpainting as you drift it so there are no hard edges.

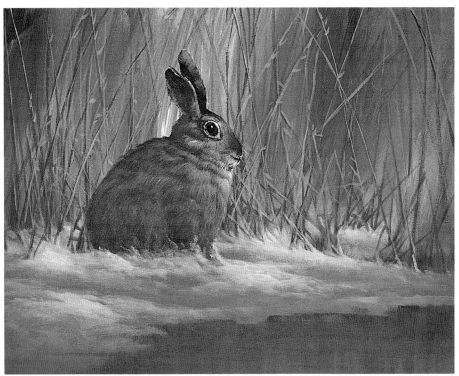

11 Underpaint Water

Apply a dark underpainting to make the water really look wet. Paint in the water area with a hake brush and a mixture of Titanium White (gesso), Ultramarine Blue, Burnt Sienna and a little Dioxazine Purple, making sure to cover the canvas completely. Include irregular shapes along the water's edge to make it appear flatter in contrast and more interesting.

12 Add Reflections of Weeds

Scrub in the basic shapes of the weeds in the water with a no. 4 round sable brush and a creamy mixture of some of the colors you used for the original weeds. Slightly wiggle your brush as you paint them in to give the impression of a slight ripple in the water. Remember to vary the values of the weed reflections. Also paint in some highlights on the reflections of the weeds.

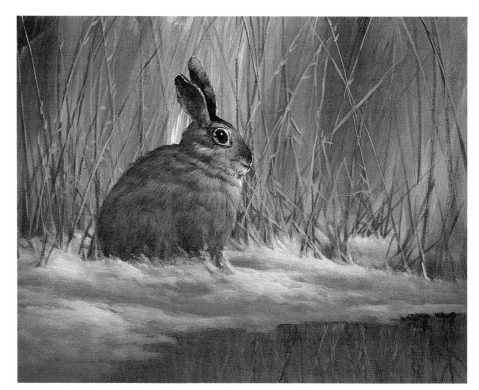

13 Highlight Water

Really make the water come alive in this step. Along the edge of the water, apply the snow highlight mixture from step 3 with a no. 10 flat bristle brush and vertical drybrush strokes of various lengths and widths. Let some of these strokes blend out into the water to create some nice pockets of negative space.

14 Glaze Water

Load a no. 10 flat bristle brush evenly across the end with a wash of Titanium White (gesso) and water. Hold the brush perpendicular to the canvas and slightly drag it across the surface of the water with a slight wiggle in the stroke. Repeat this step for the effect you want.

15 Underpaint Large Foreground Weeds

Gather your courage for this step. Paint in the long, tall weeds in the foreground with a fairly inky mixture of Burnt Sienna, Ultramarine Blue and Dioxazine Purple. Use a few different brushes—a no. 4 round sable, a no. 4 flat sable and a no. 4 script liner. Pull some of these weeds all the way to the top of the canvas, leave others short and bent over and let others overlap the rabbit. Let the weeds lean at different angles and overlap each other.

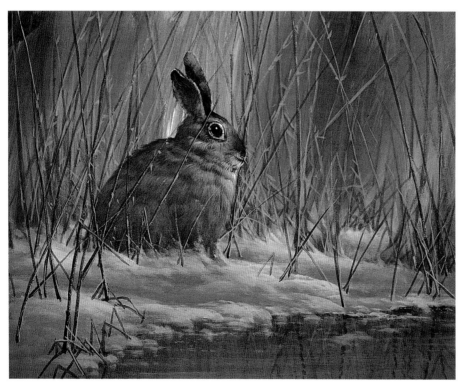

16 Highlight Foreground Weeds

Paint highlights on the right sides of most of the larger weeds with one of the brushes from step 15 and a mixture of Titanium White (gesso), Cadmium Yellow Light and Cadmium Orange. You don't have to highlight every weed. Instead, add some light-colored weeds against some of the darker areas of the background and the rabbit.

17 Add Final Details and Highlights

Now is your opportunity to enhance your painting with highlights and miscellaneous details. Add brighter highlights to the rabbit. Drift snow against the foreground weeds. Add some bright highlights along the water's edge. Put final highlights on the snowdrifts and piles of snow along the shoreline with a mixture of Titanium White (gesso) and a touch of Cadmium Yellow Light.

I hope this painting taught you to paint with softness and subtle value changes. I look forward to working with you on the next one.

Moonlight Canadians
16" × 20" (41cm × 51cm)

Moonlight Canadians

This painting offers all kinds of wonderful learning opportunities. You've heard me say that before, but this is one of my all-time favorite paintings to do. I love the intense moonlight glow. The real challenge in this painting isn't painting the geese, as you might suspect. It's managing the variety of green tones and values that give the painting its true atmosphere. Green is one of the hardest colors to work with, especially in a painting full of green tones. Done correctly, though, it can be one of the most exciting color schemes you'll ever work with. This painting will challenge you more than most, but it's well worth the experience. Your script liner will get a workout from all of the dead trees, and the water and reflections also will provide some work. The main feature, the Canadian geese, are small and not too detailed. They appear more as silhouettes against the moonlit sky than defined objects.

1 Underpaint Background

This painting has an interesting and unique color scheme. Apply a liberal coat of gesso made creamy with water over the sky area with a hake brush and long, vertical strokes. While the gesso is still wet, again use vertical strokes to apply Hooker's Green Hue, Burnt Sienna, a touch of Dioxazine Purple, a little Cadmium Yellow Light and a little Cadmium Orange. Carefully blend these colors together on the canvas until you have created a nice, rich, dark green background with subtle color and value changes.

2 Underpaint Water

Turn your canvas upside down and paint the water the same way you painted the sky.

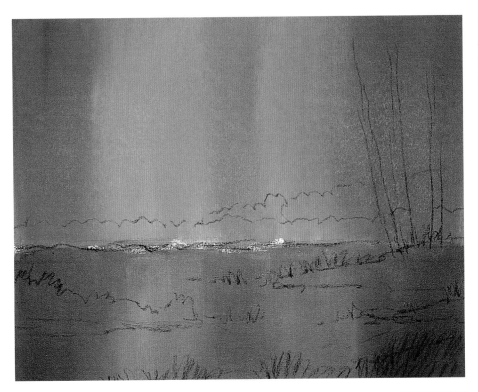

3 Draw Basic Sketch
Make a quick, rough sketch of the basic components of the land-scape with no. 2 soft vine charcoal.

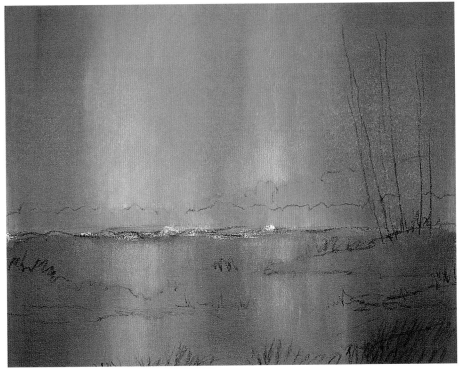

4 Add Moonlight Glow
Drybrush in a soft moonlight glow with a no. 6 flat bristle brush and a mixture of Titanium White (gesso), Cadmium Yellow Light and a very slight touch of Cadmium Orange. Carefully blend this high-light into the background so there are no hard edges. It doesn't take very much paint, so don't overload your brush.

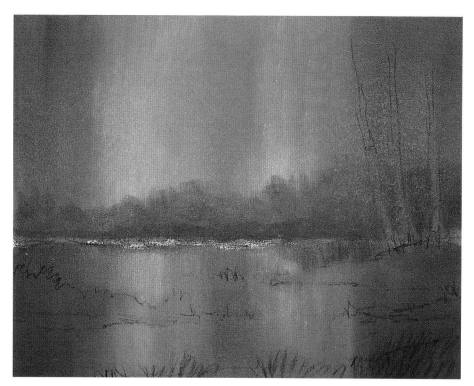

5 Underpaint Background Bushes

Make a mixture of Hooker's Green Hue, touches of Burnt Sienna and Dioxazine Purple and just enough Titanium White (gesso) that the mixture is still slightly darker than the background. Scrub in a nice collection of soft, interestingly shaped bushes with this mixture and a no. 6 flat bristle brush.

6 Paint Dead Background Trees

Slightly darken the mixture you used in step 5 with a little Ultramarine Blue and Burnt Sienna and make it fairly inky. Paint in the dead trees across the background with a no. 4 script liner. Change the value for some to add depth to the background by adding a little Titanium White (gesso) to the mixture.

7 Underpaint Shoreline

Scrub in a rough, irregular shoreline with a no. 6 flat bristle brush and a mixture of Hooker's Green Hue and touches of Dioxazine Purple and Burnt Sienna. This mixture should be slightly darker than the background trees. As you paint the shoreline, suggest a few bushes and also smudge some of the mixture into the water to suggest reflections from the bushes.

8 Paint Dead Tree Reflections

Slightly drag a no. 4 round sable brush from the shoreline vertically down the canvas with a creamy version of the dead tree mixture from step 6. Use a slight wiggle in your brushstrokes to make the water appear wetter and rippled.

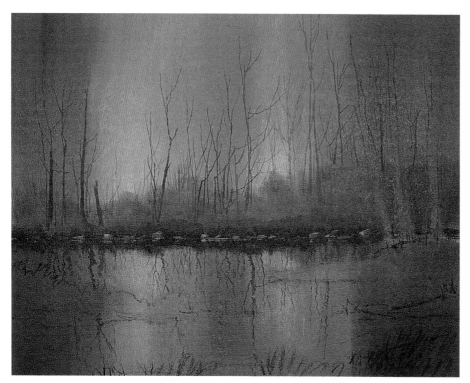

9 Add Details to Shoreline

Now you can start adding a little detail. Paint in the suggestion of rocks and other debris along the shoreline with a no. 4 flat sable brush and a creamy mixture of Titanium White (gesso), Cadmium Orange and a little Hooker's Green Hue to gray it. Keep these highlights fairly soft; they would be too obvious if they were bright. If you think they are too bright, just add a little more Hooker's Green Hue to the mixture and paint over them.

10 Underpaint Clumps of Grass

The contour of the foreground begins to take place in this step. Make a fairly creamy mixture of Hooker's Green Hue, a little Burnt Sienna and Dioxazine Purple, making sure to use enough Burnt Sienna and Dioxazine Purple to prevent the mixture from being too green. Use a no. 10 flat bristle brush and a vertical, dry-brush stroke to paint in the clumps of grass. Include pockets of negative space to give the composition good eye flow. Drybrush the reflections from each clump, making sure to keep them soft.

11 Paint Large Tree Trunks

Paint in the trunks of each of the larger trees with no. 4 round and no. 4 flat sable brushes and a very creamy mixture of Ultramarine Blue, Burnt Sienna and a little Hooker's Green Hue. Don't worry about the smaller limbs; just concentrate on what you can do comfortably with these two brushes. Use the negative space around the trees to create good balance and eye flow.

12 Paint Moon

Dab a little bit of a mixture of Titanium White (gesso) and a touch of Cadmium Yellow Light for the moon with a no. 4 flat bristle brush. Blend this color out from the moon with a dry-brush, scrubbing stroke. You may need to repeat this step to make the area bright enough. Do the same for the moon's reflection in the water.

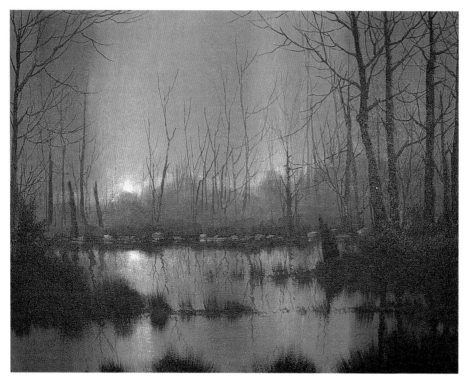

13 Add Tree Limbs

Add enough water to the mixture you used to paint the trees in step 11 to make it inky. Thoroughly load a no. 4 script liner, rolling it to a point. Add limbs to the trees in the middleground. Don't be afraid to add as many as it takes. Again, keep an eye on negative space and overlap plenty of branches.

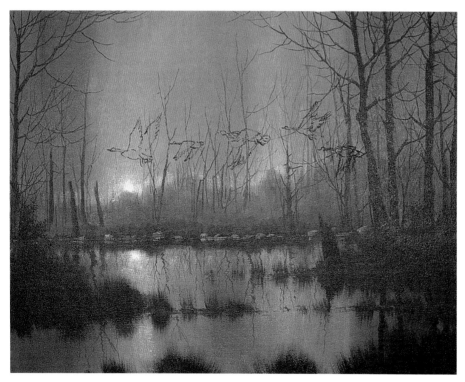

14 Sketch Geese

If you want to, sketch the geese on a separate piece of paper, then transfer them to the canvas with graphite paper and a pencil. Otherwise, sketch the geese directly onto the canvas with no. 2 soft vine charcoal.

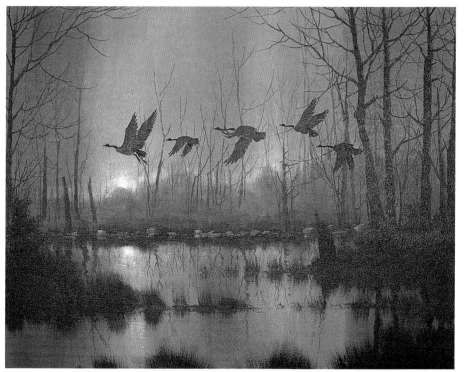

15 Underpaint Geese

Underpaint the gray areas on the geese with a no. 4 round sable brush and a fairly creamy, medium-dark mixture of Burnt Sienna, Ultramarine Blue and a little Titanium White (gesso). Block in the very dark areas on the geese with an almost black mixture of Ultramarine Blue and Burnt Sienna. Paint the patches on the heads and backs near the tails with pure Titanium White (gesso).

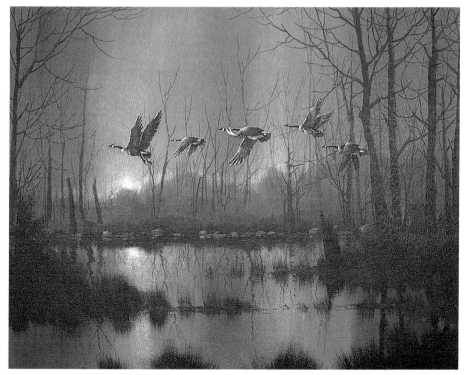

16 Add Details to Geese

Only the suggestion of detail on the geese is necessary. Drybrush in suggestions of feathers on the wings and bodies with a no. 4 round sable and a mixture of Titanium White (gesso), a touch of Cadmium Yellow Light and a little of the dark gray mixture from step 15. Just highlight the geese to give them three-dimensional form. Individual feathers shouldn't show up from this far away. Paint silver linings on the wings and various parts of the bodies with a no. 4 script liner and a mixture of Titanium White (gesso) and a little Cadmium Yellow Light, but don't completely outline each goose.

17 Add Tall Weeds

Paint in the weeds in the middleground and foreground with a no. 4 script liner and an inky mixture of Hooker's Green Hue, Burnt Sienna and Dioxazine Purple. Again, keep an eye on negative space and overlap plenty of weeds. Make some of the foreground weeds fairly tall and use a variety of shapes.

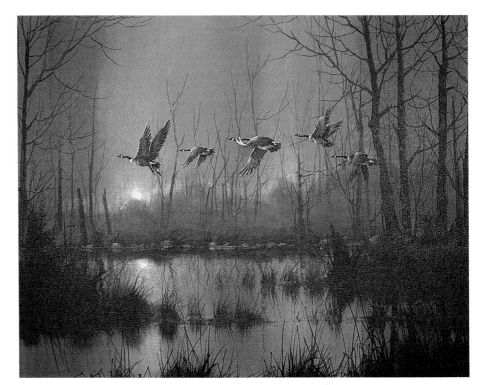

18 Add Moonlight to Trees

Paint silver linings on the edges of many of the middleground tree trunks and on a few limbs. Apply the highlights fairly thickly so they'll be opaque and bright. Don't highlight any of the small limbs; that would make the painting too busy.

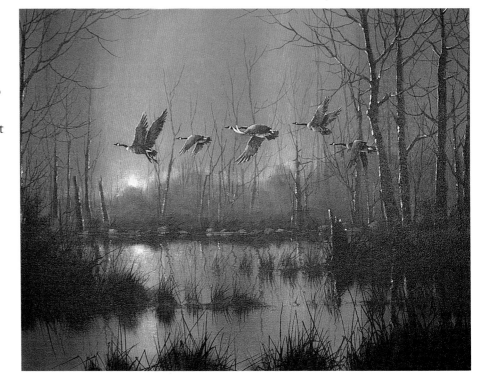

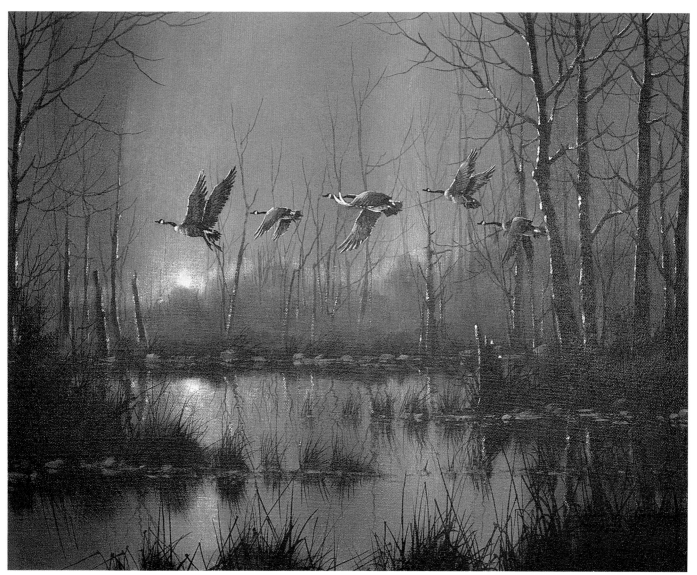

19 Add Final Details

Paint in the suggestion of rocks and other debris on the shoreline with a no. 4 flat sable brush and a mixture of Titanium White (gesso), a touch of Cadmium Orange and a touch of Hooker's Green Hue to gray it. Don't overdo it; add just enough rocks and debris to make the painting look finished. Exercise your artistic license with any other details you want to make your painting more interesting.

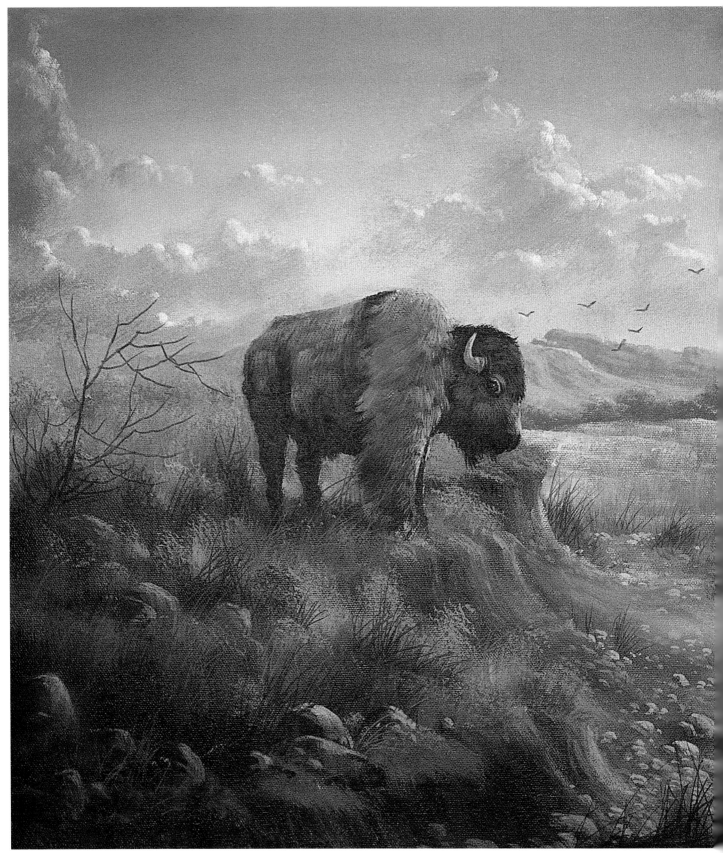

Prairie Giant
16" × 20" (41cm × 51cm)

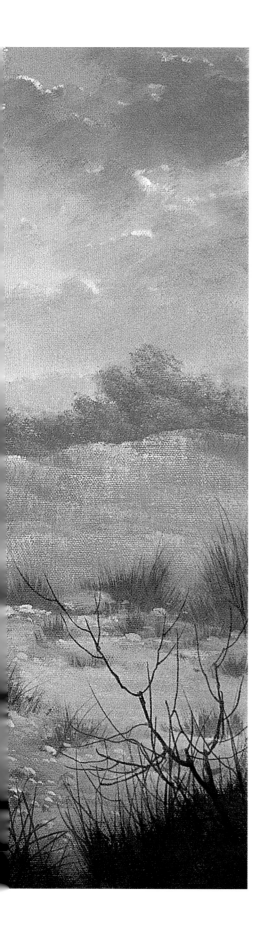

Prairie Giant

My Oklahoma roots really come through in this painting. The Midwest is filled with western and Native American traditions in which the buffalo is a symbol of freedom and power. Herds once roamed freely across Midwestern prairies until man's desire to industrialize the West met them head on. They were killed off to near extinction. With good wildlife and land management, buffalo are making a strong comeback. About an hour from my studio are thousands of acres of unspoiled prairie grassland where the largest herd roams. On one of my taping adventures for my PBS show, I photographed this large bull standing on a grassy knoll. I have painted him several times, and I couldn't pass up the chance to share this valuable learning experience with you. This is not a difficult painting. Just make sure background and accent objects don't compete with the buffalo for attention. Keep the landscape simple. You'll learn grass and fur techniques and, if nothing else, a bit of buffalo history!

1 Draw Basic Sketch

Make a quick, rough sketch of the basic components of the landscape with no. 2 soft vine charcoal. Don't get carried away with detail; just keep it simple.

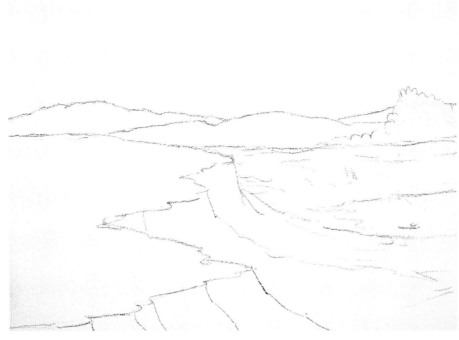

2 Underpaint Sky

Lightly wet the sky. Then apply a liberal coat of gesso with a hake brush. While the gesso is still wet, apply Cadmium Yellow Light and a touch of Cadmium Orange at the horizon and blend upward about three-fourths of the way to the top of the canvas. While the paint is still wet, apply a mixture of Ultramarine Blue and touches of Dioxazine Purple and Burnt Sienna at the top of the canvas. Blend down into the horizon color until you have a nice, soft underpainting.

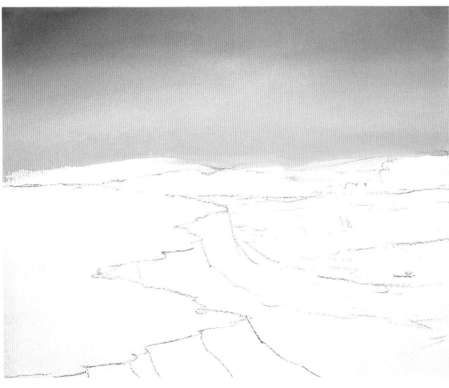

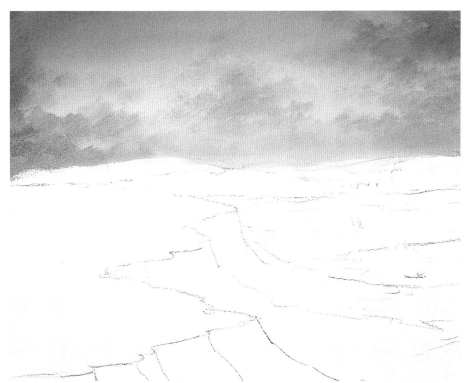

3 Add Clouds

Make a mixture of Titanium White (gesso) and touches of Ultramarine Blue, Burnt Sienna and Dioxazine Purple. The mixture should be slightly darker than the sky. Scrub in nice collections of clouds with a no. 6 flat bristle brush. Use a well-balanced arrangement of negative space to create good eye flow. Make sure the edges of the clouds are soft and fade nicely into the background.

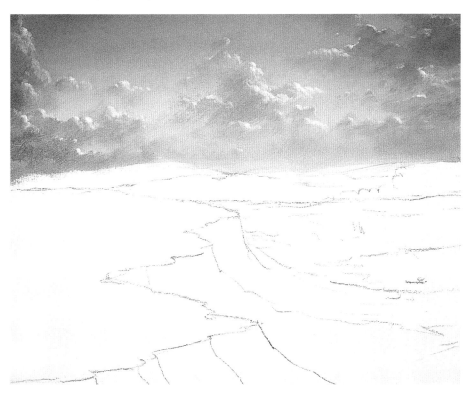

4 Highlight Clouds

Carefully highlight the top right-hand sides of most of the cloud formations with a no. 4 flat bristle or sable brush and a mixture of Titanium White (gesso) and a slight touch of Cadmium Orange. The clouds in the right-hand side of the sky are flatter and have silver linings instead of highlights to indicate three-dimensional form. Repeat this step once or twice if you want brighter highlights on the clouds.

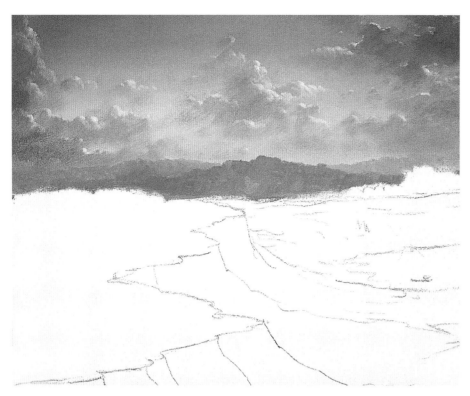

5 Underpaint Background Hills

Make a mixture that is slightly darker than the color at the horizon with Titanium White (gesso) and touches of Dioxazine Purple, Burnt Sienna and Ultramarine Blue. Scrub in the shapes of the very distant hills with this mixture and a no. 4 flat bristle brush. Make the mixture slightly darker and scrub in the basic form of the closer row of background hills. Give these hills more distinct form to make them appear more rugged. The extra form and detail also will make them appear closer.

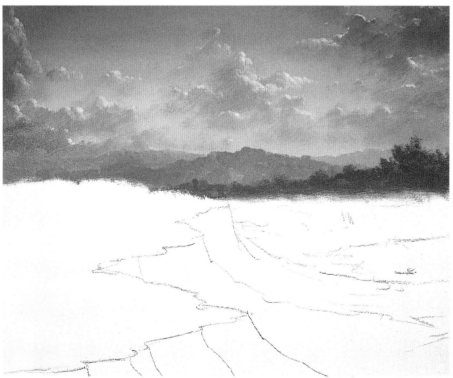

6 Underpaint Distant Trees

Add a little more Dioxazine Purple and a touch of Hooker's Green Hue to the mixture from step 5 to darken it. Scrub in the basic shapes of these distant trees with a no. 4 or no. 6 flat bristle brush. Keep these shapes simple because there are not many trees. Also make sure they have nice pockets of negative space to create good eye flow.

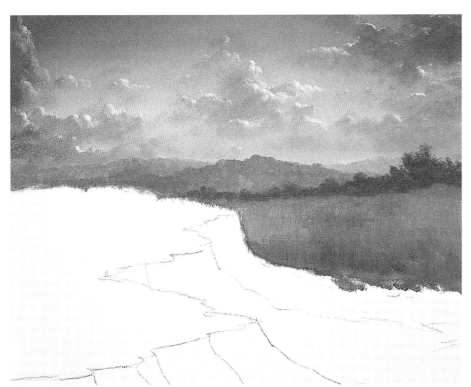

7 Underpaint Middleground Grass

Add a little Cadmium Orange and a bit more Titanium White (gesso) to the mixture from step 6 to create a nice, soft, midtone gray-green. Use a series of overlapping, vertical dry-brush strokes and a no. 10 flat bristle brush to underpaint the grass in the middle right of the painting. Begin at the top of this area and work your way down. Allow your brushstrokes to show, suggesting blades of grass. When you reach the bottom of the grassy area, leave an irregular edge to drift the dirt in and around.

8 Underpaint Foreground Bank

Paint the bank in the foreground with a no. 6 flat bristle brush and a mixture of Burnt Sienna and a little Dioxazine Purple. Start at the top of the bank and work your way down to the flat area using a large comma stroke. Add touches of Titanium White (gesso) and Cadmium Orange as you go. As your strokes flatten out, let them become choppy and horizontal to suggest dirt. Use a variety of light and dark values that contrast each other to give the bank depth and character. Play with the design. Just make sure the banks are darker at the top so the lighter grass that overlaps the bank will show up well when you paint it in step 9.

9 Underpaint Foreground Grass

Scatter different combinations of Titanium White (gesso), Cadmium Yellow Light, a little Hooker's Green Hue and touches of Dioxazine Purple and Burnt Sienna with vertical, dry-brush strokes. Start at the top and move across the grassy area on top of the bank. As you move forward, continue changing the combinations and values of the colors to create nice contrast. I made the bottom left corner much darker than the rest of the painting.

10 Highlight Background Hills and Trees

Highlight just enough of the background hills with a no. 4 flat sable brush and a mixture of Titanium White (gesso) and a little Cadmium Orange to give them a little three-dimensional form. Add a little more Titanium White (gesso) and a touch of Phthalo Yellow-Green to the mixture, and dab highlights on the distant trees with a no. 4 or no. 6 flat bristle brush. Again, highlight the trees just enough to provide a little form.

11 Highlight Middleground Grass

Load just a little of a fairly creamy mixture of Titanium White (gesso) and touches of Phthalo Yellow-Green and Cadmium Orange on the end of a no. 10 flat bristle brush. Add highlights to the grass with a vertical, dry-brush stroke, starting at the top of the grassy area and working your way down. Leave pockets of negative space to give the grass contour. It should have a gentle, rolling effect, so don't line the highlights up in a horizontal row.

12 Paint Clumps of Grass

Make a mixture of Hooker's Green Hue, a touch of Dioxazine Purple and enough Titanium White (gesso) to make the value fit this area of the painting. Drybrush in the individual soft clumps of grass with this mixture and a no. 6 flat bristle brush. Include good negative space and eye flow around the clumps, but don't line them up in a row. These clumps serve as the transition between the back- and foregrounds.

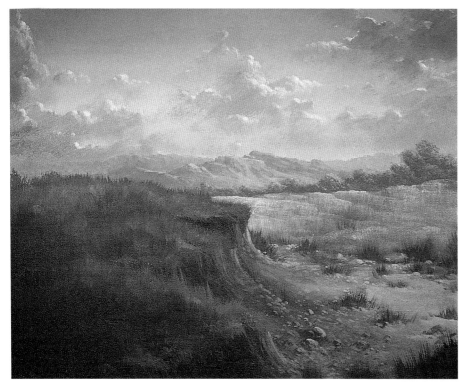

13 Add Foreground Rocks

Suggest the pebbles and small rocks with no. 4 round and flat sable brushes and a mixture of Titanium White (gesso), a touch of Cadmium Orange and a slight touch of Cadmium Yellow Light. Use small, rounded strokes. For the larger rocks, paint darker form shadows and then highlight them with the color you used to paint the pebbles. Don't worry about bright highlights yet.

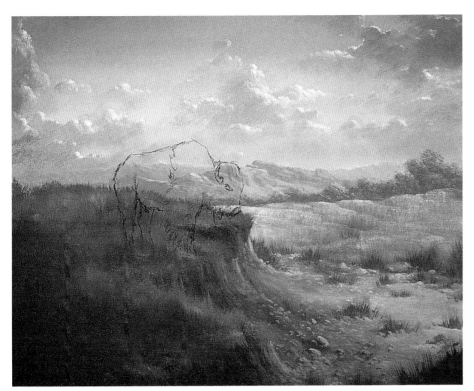

14 Sketch Buffalo

Make an accurate sketch of the basic form of the buffalo. It doesn't need to be detailed, but the form must be accurate. Sharpen the end of a piece of no. 2 soft vine charcoal just a little to make it easier to sketch with.

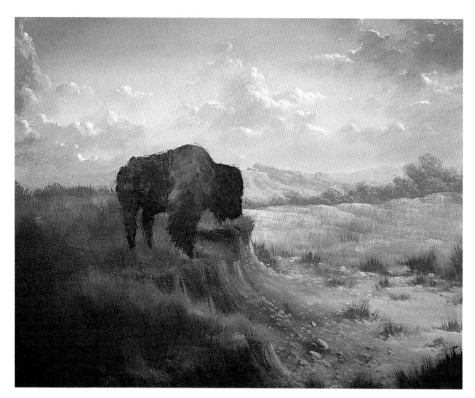

15 Underpaint Buffalo

Block in the entire buffalo with a no. 4 flat bristle brush and a dark mixture of Burnt Sienna, Ultramarine Blue and just a little Titanium White (gesso). Darken the mixture's value to paint darker areas, such as the shadows beneath the buffalo and areas where the buffalo's body parts overlap. Avoid a hard edge or outline around the body, but cover the canvas well.

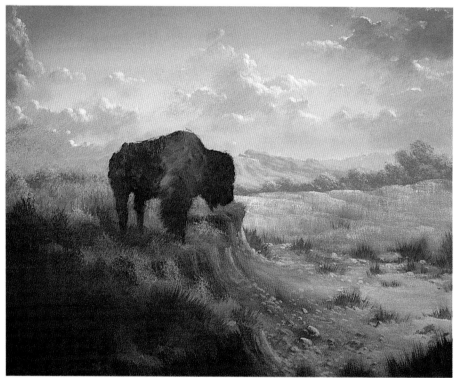

16 Add Bushes and Grass

Make several mixtures of different values with Titanium White (gesso), touches of Cadmium Yellow Light and Phthalo Yellow-Green and a little Cadmium Orange. Dab in the highlights on the grass in the left middleground with a no. 4 or no. 10 flat bristle brush to create small bushes and clumps of grass. Don't make this area too busy. You may even need to add some darker areas to create contrast.

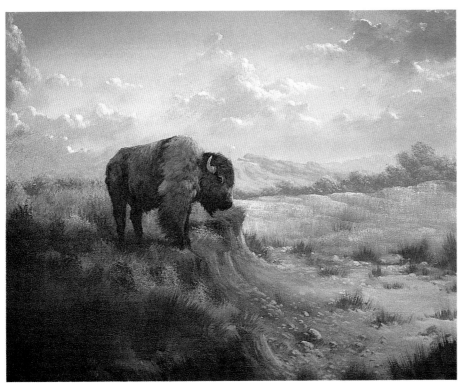

17 Add Details to Buffalo

Load the very end of a no. 4 flat sable brush with a small amount of a fairly creamy mixture of Titanium White (gesso) and touches of Cadmium Orange and Cadmium Yellow Light. Starting at the top of the buffalo, suggest the hair with a very light, dry-brush stroke. Follow the contour of the body, and allow some of the background color to come through to create depth. Include light and dark areas to give the buffalo form; don't make the buffalo one tone.

18 Add More Details to Buffalo

Again darken some of the shadow areas on the buffalo to create a little more depth with a no. 4 round sable brush and a dark mixture of Burnt Sienna and Ultramarine Blue. Soften any hard edges with the same brush and a mixture of Titanium White (gesso) and touches of Cadmium Yellow Light and Cadmium Orange. Make sure all of the final highlights are opaque so they will stay nice and bright.

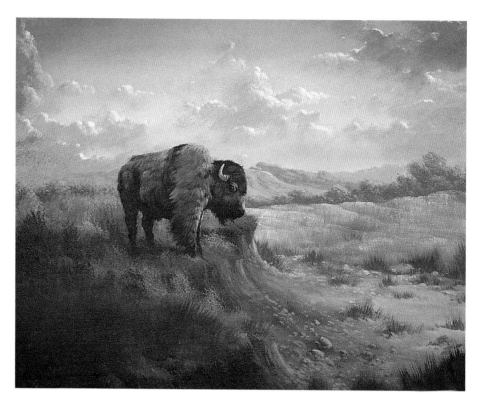

19 Add Foreground Rocks and Dead Bushes

Block in the dark sides of the rocks on the grass above the bank with a no. 4 flat bristle brush and a mixture of Burnt Sienna, a little Ultramarine Blue, a little Dioxazine Purple and a little Titanium White (gesso) to soften it. Add form highlights to the rocks with the same brush and a mixture of Titanium White (gesso), Cadmium Orange and a slight touch of the rock mixture from step 13 to gray it. You'll add brighter highlights in step 20. Thin the first mixture you used in this step to an inky consistency. Paint in the two dead bushes with this mixture and a no. 4 script liner.

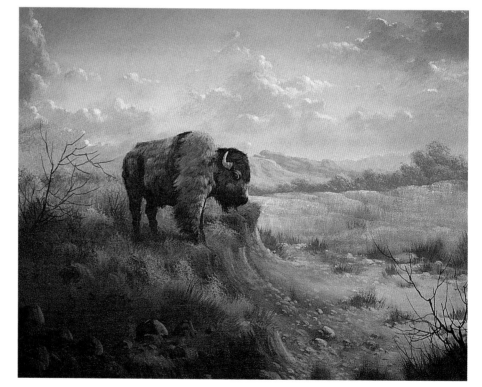

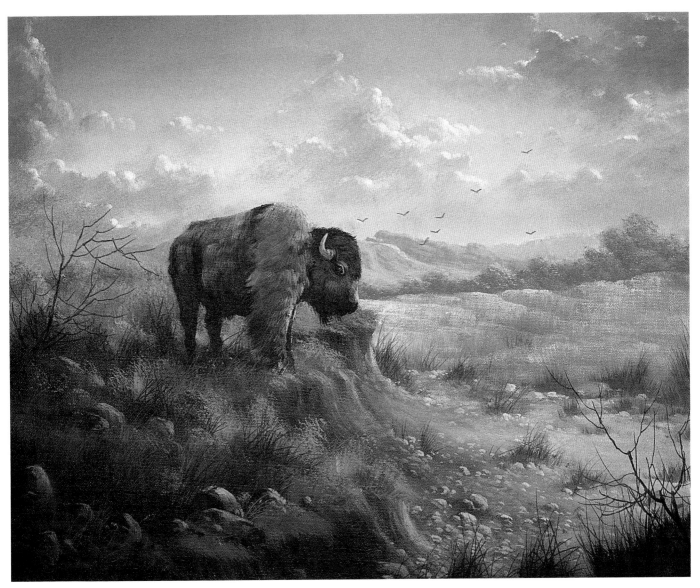

20 Add Final Details

Give your painting some personality in this step. Add elements like taller weeds, a few wildflowers and brighter highlights on the rocks and pebbles. Highlight some of the clumps of grass, but don't make the painting too busy.

I sincerely hope you learned a lot from this painting. It was great fun sharing it with you. Keep up the good work and remember that practice, practice, practice is the key!

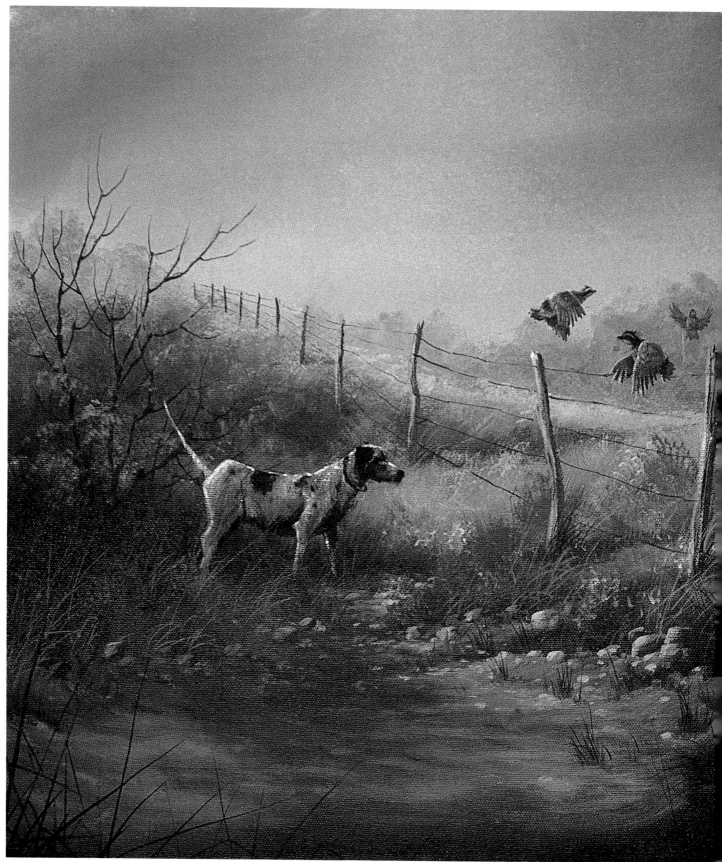

Covey Raider
16" × 20" (41cm × 51cm)

Covey Raider

Another memory of mine plays a role in this painting. I never was a great hunter, but one of my favorite things to do as a child was to walk through the high brush, climb over barbed wire fences and try to flush out a covey of these elusive, upland game birds. Over the years I probably have painted more quail than any other bird. This painting offers a wide range of subjects and techniques. The landscape is fairly impressionistic, so you'll have an opportunity to work on grass, brush and foreground details. Even the dirt wash and the rocks and pebbles are fun to paint, and they really add to the foreground. The old fence is another exciting subject. Just make sure you use proportions correctly as the posts recede into the background. The quail and the dog provide a challenge. Proportion, again, and location are the keys to painting these animals. Don't let the amount of activity in this painting scare you. The learning experience matters most.

1 Draw Basic Sketch
Once again, make a rough sketch of the basic components of the landscape with no. 2 soft vine charcoal.

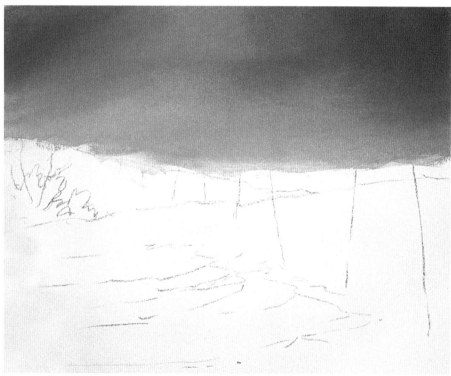

2 Underpaint Sky
Lightly wet the sky area and apply a liberal coat of gesso with a hake brush. Apply Alizarin Crimson at the horizon and blend it all the way to the top of the canvas. Then apply a mixture of Ultramarine Blue and little touches of Dioxazine Purple and Burnt Sienna at the top of the canvas and blend downward almost to the horizon. Clean your brush a bit and go back over the sky with large, crisscross, feather strokes.

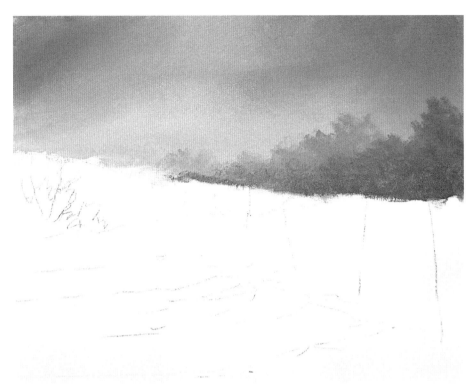

3 Underpaint Background Trees

Make a mixture that is slightly darker than the sky with Titanium White (gesso), a little Ultramarine Blue, a little Burnt Sienna and a little Dioxazine Purple. Scrub in some soft, distant trees with a no. 6 flat bristle brush. Slightly darken the mixture and scrub in another group of trees just in front of the background trees. Make sure both groups of trees produce good eye flow and have soft edges.

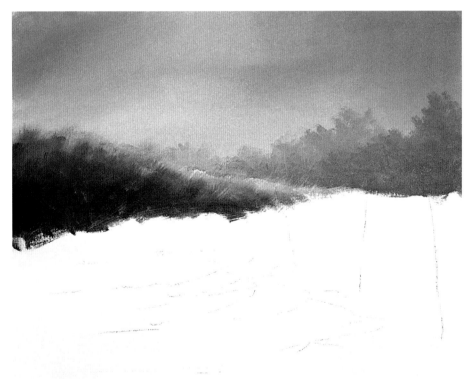

4 Underpaint Grassy Middleground

Scrub in the grassy area with a no. 10 flat bristle brush and a variety of mixtures of Titanium White (gesso); touches of Cadmium Yellow Light, Cadmium Orange and Phthalo Yellow-Green; and occasionally a little Burnt Sienna. Use mostly golden, earth tones. Scrub in darker, contrasting areas to suggest bushes or clumps of grass with a mixture of Burnt Sienna, touches of Dioxazine Purple and Hooker's Green Hue and a little Titanium White (gesso) to soften it. Use loose, impressionistic strokes in this step.

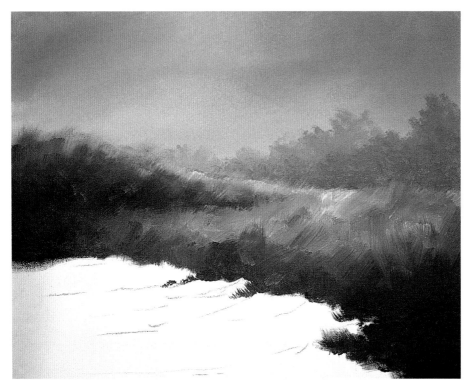

5 Underpaint Grassy Foreground

Paint this area the same way you painted the grass in step 4, but give more definite shape to the bushes. Paint in different bush shapes with a no. 10 flat bristle brush, using a variety of contrasting values. Add Hooker's Green Hue, Dioxazine Purple and Burnt Sienna to the mixture from step 4 to make a darker color that will provide contrast. The new mixture should be a richer, olive color just perfect for the foreground. Keep your strokes loose and free.

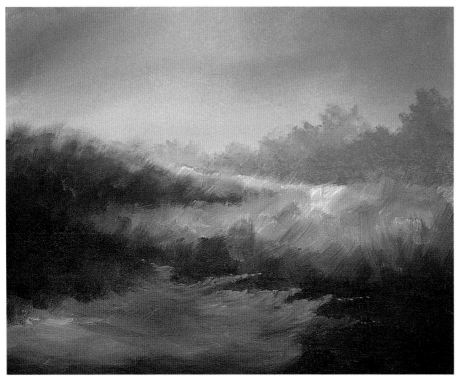

6 Underpaint Dirt

Starting at the little bank on the bottom right, use a no. 6 flat bristle brush and a comma stroke to apply a mixture of Titanium White (gesso), Cadmium Yellow Light, a touch of Dioxazine Purple and plenty of Burnt Sienna. As you move into the flat area, apply Titanium White (gesso), Cadmium Yellow Light and Burnt Sienna to the canvas, blending them together to create a nice, warm earth tone. Let your brushstrokes show for texture.

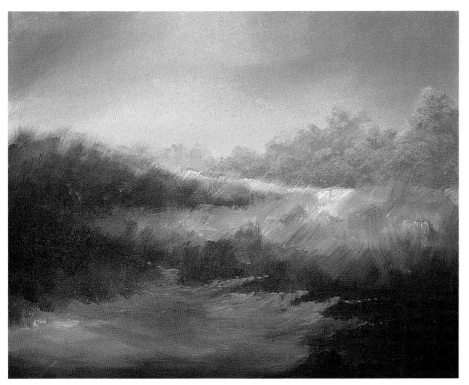

7 Highlight Background Trees

Carefully dab on a highlight mixture of Titanium White (gesso) and touches of Cadmium Orange and Phthalo Yellow-Green with a no. 6 flat bristle brush, being careful not to cover up the background color completely. Include pockets of negative space to provide good eye flow and form.

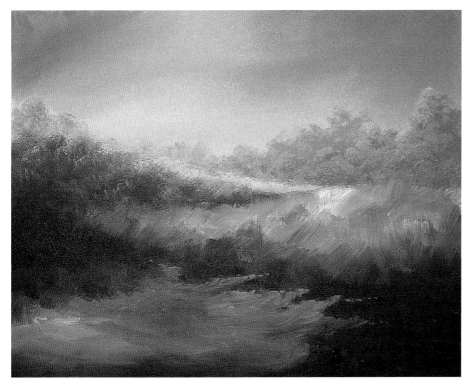

8 Highlight Background Bushes

Use no. 4 and no. 6 flat bristle brushes and bright highlight colors with a variety of loose, free strokes to create a late afternoon, sunlit effect on the grass and bushes on the middle left of the painting. Use no. 4 round and flat sable brushes for the smaller areas.

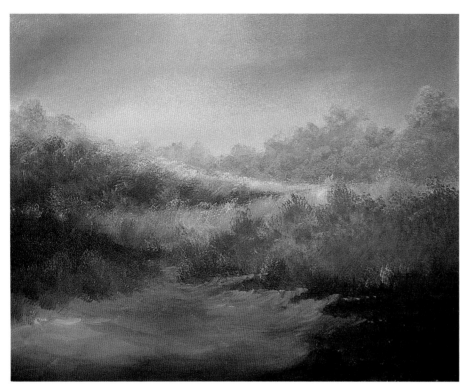

9 Highlight Middleground Grass

Paint this grass the same way you painted the grass in step 8. Use fairly loose, impressionistic strokes with whatever brush fits the job, but make the bushes and clumps of grass more distinct. Use fairly pure colors, such as Cadmium Orange, Cadmium Yellow Light and Phthalo Yellow-Green to create an array of grass and bushes with different textures, shapes and forms and contrasting values.

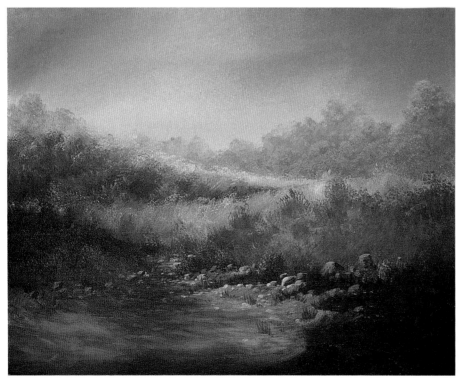

10 Add Details to Dirt

You probably know by now that I can't let you get through a painting without adding a few rocks and pebbles. Make little, rounded highlights to suggest pebbles with no. 4 round and flat sable brushes and a mixture of Titanium White (gesso), a touch of Cadmium Orange and a touch of Dioxazine Purple to slightly gray it. Place some rocks and pebbles along the edge of the grass to suggest erosion, but keep most of them around the outer edge of the dirt area. For the larger rocks, paint a form with a darker value first and then highlight it with the highlight color.

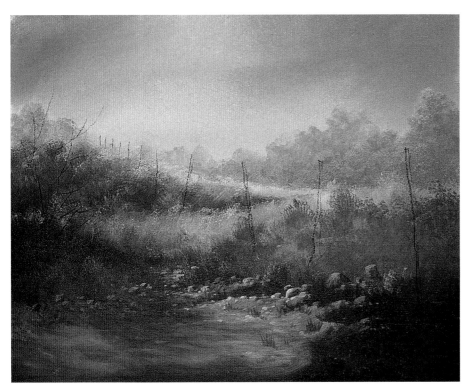

11 Sketch Foreground Bush

Draw a rough but accurate sketch of the fence posts and the dead bush on the left with no. 2 soft vine charcoal. Make sure you get the correct location and perspective of the fence in your sketch before you paint it in.

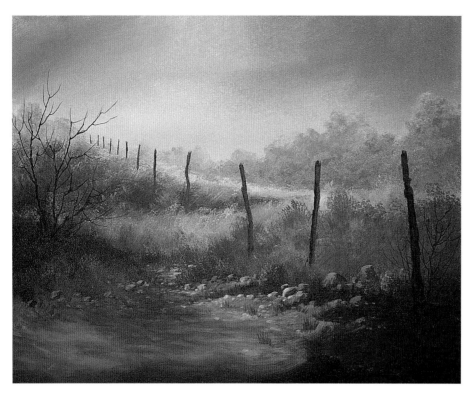

12 Underpaint Fence and Bush

Paint the fence posts with a no. 4 flat sable brush and a mixture of Burnt Sienna and Ultramarine Blue. Hold the brush perpendicular to the canvas for better control while painting the crooked post shapes. Add Titanium White (gesso) to the mixture to lighten the value for each fence post as the posts recede into the background. Thin the mixture you used for the first fence post—the darkest one—to an inky consistency and paint in the dead bush with a no. 4 script liner.

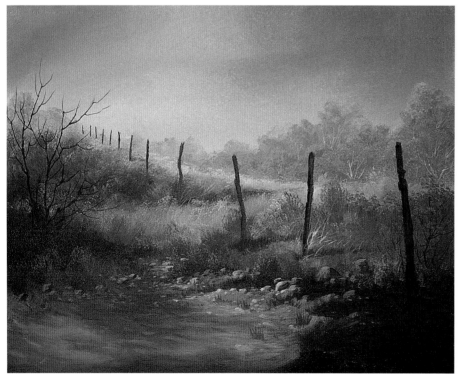

13 Add Details to Landscape

Once you paint the fence and wire, painting more details around them is difficult, so take the time right now to analyze your background. Paint the trunks on the distant trees, shadows from the fence posts, weeds, flowers, more or brighter highlights and any other additional accents you want to include.

14 Add Details to Fence

Highlight the fence posts with a no. 4 round sable brush and a mixture of Titanium White (gesso) and touches of Cadmium Orange and Cadmium Yellow Light. Use short, choppy, vertical dry-brush strokes to suggest weathered wood. Allow some of the background to show through to make the posts appear rugged. Carefully paint in the wire with a no. 4 script liner and a very inky mixture of Ultramarine Blue and Burnt Sienna. Practice this first if you need to.

15 Add More Details to Foreground

Add a variety of weeds in different colors and values to tie the painting together. Add weeds and suggest flowers to settle the fence posts. Add a few more pebbles and highlights on the dirt. Don't overwork the foreground or it will compete with the dog and quail.

16 Sketch Animals

Use a sharpened charcoal pencil to accurately sketch the animals. Practice on a sketch pad to get the shapes and forms right before drawing on the canvas.

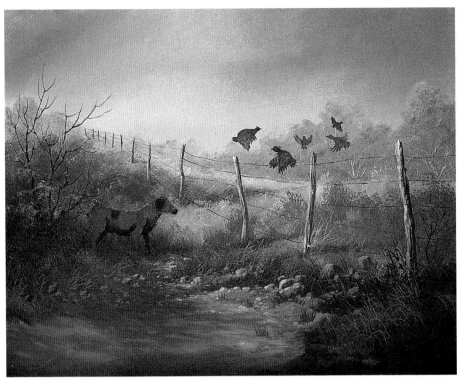

17 Underpaint Animals

Carefully underpaint the dog with a no. 4 flat sable brush and a gray mixture of Ultramarine Blue, Burnt Sienna and a touch of Titanium White (gesso). Don't leave a hard outline around the dog's outer form. Darken the value of the mixture with more Ultramarine Blue and Burnt Sienna to paint the spots and shadow areas. Slightly lighten the new mixture with Titanium White (gesso) to underpaint the quail with a no. 4 round sable brush.

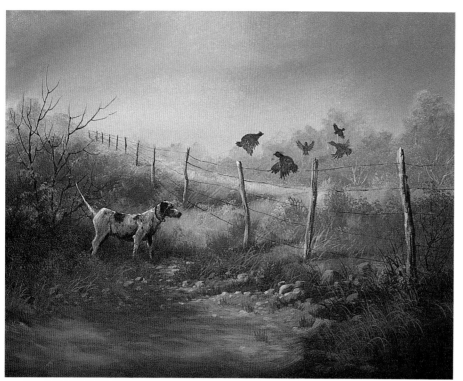

18 Add Details to Dog

Make the original under-painting color from step 17 much lighter and then add a touch of Cadmium Orange. Load just a little bit of a creamy version of this mixture on the end of a no. 4 flat sable and carefully drybrush highlights on the dog's back, following the contour of the body with a very light stroke. The highlight gradually should darken as you move downward. Add some brighter highlights along the dog's back, head, tail and legs with a no. 4 round sable brush. Don't paint a hard line around the dog.

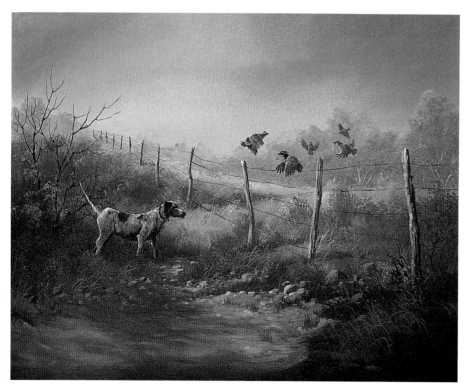

19 Add Details to Quail

Drybrush a few highlights around the outer edges of the bodies and wings with a no. 4 round sable and a mixture of Titanium White (gesso) and a touch of Cadmium Orange to suggest form and define the wings. Add some simple, delicate highlights on the wing tips to suggest individual feathers. Add the dark accents on the heads and beaks and inside the wings and tails with a darker mixture of Burnt Sienna, Ultramarine Blue and a little Titanium White (gesso) to soften it. Use simple, quick strokes and don't overdo it. If you goof up, simply underpaint the area and reapply the highlights.

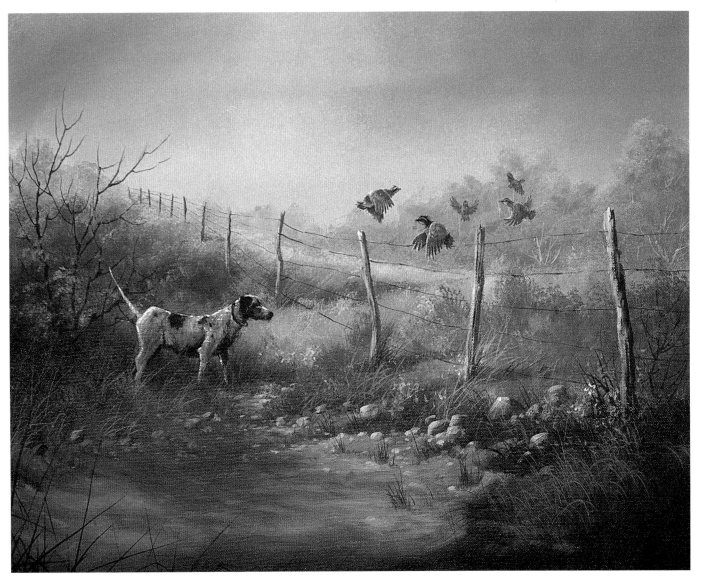

20 Add Final Highlights

Pull up a few weeds under the dog to settle it down. Add some bright, orange leaves on the bushes and maybe a brighter highlight on the top of the dog with pure Titanium White (gesso). Stand back, analyze the whole painting and make any final adjustments you want.

This was a fun experience and a great learning opportunity! In fact, this would be a great painting to try in different seasons and with different game birds like pheasants or grouse.

Index

A

Accenting. *See* Highlighting
Acrylic paints. *See* Colors, mixing; Paint
Alcohol, 12
Animals, 122. *See also* Buffalo; Chipmunks; Deer; Dog; Fur; Moose; Rabbit; Squirrels

B

Background, 76, 88
Bank. *See* Shoreline
Bark, 71
Birds, 63, 113, 125. *See also* Eagle; Feathers; Geese; Pheasants; Quail
Blocking in. *See* Underpainting
Branches. *See* Tree limbs
Brush control, 75
Brush, diagram, 13
Brushes, 11–12, 24–25
Buffalo, 98–99, 107–110
Bushes, 91, 108–109, 119
 background, 90, 117
 dead, 60, 110, 119–20
 highlighting, 117
 underpainting, 90, 120

C

Camera, 36
Canvas, 11, 16
Charcoal pencil, 11, 70, 122
Charcoal, soft vine, 11, 17–18. *See also* Sketching
Chipmunks, 75
Church, 57, 59
Church in the Wildwoods, 22
Clouds, 34–35, 65, 101
 drybrushing, 55
 highlighting, 35, 66, 101
Color complements, 8

Colors, mixing, 9, 11
 base gray, 27
 black, 79
 clouds, 55
 moonlight, 89
 night sky, 31
 pine trees, 43–44
 silver lining, 51
Composition, 21
Contemplation, 25
Covey Raider, 112–13

D

Dabbing, 8
Deer, 18
Details, 60, 122
 final, 29, 51, 73, 85, 97, 111
Dirt, 103, 116, 118, 122
Dirt Wash, 113
Dog, 113, 122–24
Double load, 8
Drybrush, 8, 10–11
 clouds, 55
 dog, 124
 feathers, 72, 95
 fur, 49, 75
 grass, 104–106
 light, 32
 moon, 61
 mountains, 67
 trees, 71

E

Eagle, 70, 72–73
Easel, 11, 16
Evening Prayers, 34, 52–53
Eye flow, 8, 69. *See also* Negative space

F

Feathering, 8
Feathers, 24–25, 95, 124. *See*

also Birds; Eagle; Geese; Pheasants; Quail
Fence, 113, 119–20
Film, 36
Flowers, 14, 120
Fog, 29
Fur, 24–25, 75, 99. *See also* Buffalo; Deer; Dog; Moose; Rabbit

G

Geese, 87, 94-95
Gesso, 8-9, 11
Giant of the Yellowstone, 40–41
Glaze, 9, 46, 83. *See also* Wash
Grass, 99, 105, 108, 117
 clumps, 58, 92, 106, 108
 foreground, 50, 115
 highlighting, 50, 105, 111, 118
 middleground, 103, 105, 115, 118
 underpainting, 47, 92, 103–4, 115–16
Green tones, 87
Ground, rocky, 68. *See also* Dirt; Rocks
Guardian, The, 62–63

H

Hair, 24–25
Haze, 29–30
High Country Falls, 39
Highlighting, 9, 37, 51, 61, 73, 85, 120, 125. *See also* under individual entries
Hills, 102, 104

I

Icicles, 59
Impressionistic technique, 113

Check out these other great North Light titles!

Learn how to act upon your artistic inspirations and appreciate the creative process! This book shows you how to express yourself no matter what unusual approach your creations call for! Experiment with and explore your favorite medium through dozens of step-by-step mini demos. Start today and make your artistic dreams a reality!

ISBN 1-58180-102-5, hardcover, 144 pages, #31790-K

Inside you'll find more than 1,000 definitions and descriptions—every art term, technique and material used by the practicing artist. Packed with hundreds of photos, paintings, mini demos, black-and-white diagrams and drawings, it's the most comprehensive and visually explicit artist's reference available.

ISBN 1-58180-023-1, paperback, 512 pages, #31677-K

Capture the splendor of nature in your paintings with realistic trees and foliage. This compilation of classic North Light instruction features advice from a prestigious gathering of landscape artists, each one a master of rendering realistic trees and foliage in watercolor, pencil, charcoal, pen and ink, oil, acrylic or pastel.

ISBN 1-58180-187-4, paperback, 128 pages, #31925-K

Claudia Nice introduces you to the joys of keeping a sketchbook journal along with advice and encouragement for keeping your own. Exactly what goes into your journal is up to you: Sketch quickly or paint with care. Write about what you see. The choice is yours—and the memories you'll preserve will last a lifetime.

ISBN 1-58180-044-4, hardcover, 128 pages, #31912-K

These books and other fine North Light titles are available from your local art & craft retailer, bookstore or online supplier or by calling 1-800-448-0915.